Forgotten

for

TALES

of

ILLINOIS

Bryan Alaspa

illustrations by
Kyle McQueen

Charleston London

THE
History
PRESS

Published by The History Press
Charleston, SC 29403
www.historypress.net

First published 2009

Manufactured in the United States

ISBN 978.1.59629.742.5

Library of Congress CIP data applied for.

Introduction

To much of the country, the state of Illinois is one you fly over or drive through as quickly as possible. If the state is known for anything, it is the city of Chicago and probably the fact that Abraham Lincoln once lived and worked here. People forget that this state was once the westernmost edge of the country. They forget that the state is full of history.

The Mississippi River runs the length of Illinois, forming the western edge. This has brought interesting things to the state as those who traveled up and down that major waterway bore their traditions and music with them. It is a state filled with hardworking people who don't worry too much about what the rest of the country, or the rest of the world, thinks about them.

I have lived in this state my entire life. I was born and raised in Chicago and spent much of my life learning

about my home state. In every Illinois student's classroom, there is a time when history class turns toward home. There are also trips to places like Springfield to visit the Lincoln sites.

Illinois is long and extends nearly into the South, giving it an interesting Civil War history. It has also been a major thoroughfare for riverboats, trains, cars and airplanes. The history of its largest city, Chicago, lends the state a major foothold in a number of history books.

At the same time, the state is littered with smaller towns, and each of these has its own unique history and its own unique people. While much of the state seems to be filled only with cornfields and farmhouses, these, too, have their histories.

The people who live here often don't know the history of their own state. It has been an eye-opening experience for me, looking up and studying these strange, interesting and all-too-forgotten tales of an amazing state filled with unique people. These tales may have been forgotten by most, but they deserve to be remembered somewhere. I hope that this place is here.

So sit back and enjoy. While this may be a lesson in history, it is a lesson in the strangest parts of history. It is a part of Illinois that you may not know and that shouldn't be forgotten. It has helped make the state and the people who live here what they are today.

Forgotten Tales of Illinois

The Fort and the City

The city known as Chicago began as a field of wild onions, giving it the name *Chekagou*. This name first began appearing on maps as early as 1684. By 1779, the area was known as a trading post owned by a man named Jean Baptist du Sable. The trading post eventually became a fort known as Fort Dearborn.

By 1810, the fort was manned by Captain Nathan Heald. He was a well-respected man, with years of experience behind him. He was also no stranger to the frontier, which Chicago, or Fort Dearborn, still was at that point. Things ran well for a couple of years, until the War of 1812 broke out.

The war ravaged the Indian lands in America. The Indian tribes in and around Fort Dearborn were aggravated and

easily roused. Many of them had decided to form alliances with British forces after determining that the Americans were invaders and not allies. The British captured a garrison at Mackinac, and it looked like the next fort on the list was Fort Dearborn. Heald soon received orders from General William Hull that he should abandon the fort and leave everything behind to the Indian tribes.

Heald delayed giving the orders for evacuation, and the local tribes moved in and surrounded the fort. The terrified soldiers watched from the walls as a large contingent of Indians laid siege to the fort. The soldiers began expressing their concern. Heald decided that it might be time to negotiate.

On August 12, Heald and a few of his officers marched out of the fort and held council with the Indians. Witnesses reported that there were about five hundred Indians camped outside. Heald proposed to the Indian chiefs that he would distribute what stores were left at the fort, along with ammunition, in exchange for safe passage to Fort Wayne. The chiefs agreed.

Heald thought that he had achieved something that would benefit everyone and probably figured he would be greeted as a wise hero upon returning to the fort. Instead, his remaining officers confronted him and questioned his wisdom. They felt that all of the stores and ammunition could be used against them, and Heald caved again. He and his officers broke apart the weapons and extra ammunition and dumped them down a well,

while the stores of whiskey were emptied into a nearby river. This was easily noticed by the Indians outside the fort, and they decided that they didn't need to keep their side of the bargain. Instead, they began making their own plans.

On August 14, Captain William Wells managed to get himself and thirty Miami warriors past the Indians and to the fort's front gate. Wells was a frontier legend who had been captured by Indians as a child and raised by them. Wells spoke to the Indians outside, and a second council was held.

The Indians expressed their anger at the dumping of the stores and ammunition but agreed to allow those in the fort safe passage to Fort Wayne. Heald was told that he and his men would need to abandon the fort immediately. Of course, by now the fort held more than just Heald and his soldiers. There was now a caravan of soldiers, horses, wagons, families and animals ready to receive safe passage to Fort Wayne.

The caravan was escorted out of the fort by nearly five hundred Potawatomi Indians. They marched in a southward direction, a steady column of clanking carts and anxious soldiers. Hardly anyone noticed as the Potawatomi escorts began moving quietly to the right, subtly putting an elevation of sand between them and the column of people and provisions.

The scouts and guides began milling around at the front of the column, and all hell broke out at the rear.

Captain Wells raised an alarm that the Indians were attacking. The soldiers were caught completely off guard. The officers managed to rally and form the soldiers into battle formations. It was a valiant effort, but it was already too late. As the Indians began firing on the column, so many men fell in the first rounds that giant holes were ripped in the line. The Indians were too numerous, and they swarmed around the column of men, women, horses and carts.

What happened next was sheer slaughter. Officers were tomahawked. The fort's surgeon was shot down in a hail of bullets and literally cut into pieces. The wife of one soldier was seen fighting valiantly but was then hacked into pieces before finally falling. Mrs. Heald was wounded by gunfire but was spared by a sympathetic Indian chief. By the time the garrison surrendered, 148 members of the column lay dead in the field.

Captain Wells managed to survive the massacre and was taken prisoner. He was so enraged at the death and carnage that he fought his way through his captors, found a horse and took off. The bullets missed him, but his horse was not so lucky and fell. Two Indian chiefs stepped forward to plead for the life of Wells, but Pesotum, a Potawatomi chief, stabbed Wells in the back and killed him. His heart was then cut out and distributed to the various Indian warriors as a sign of bravery.

Captain Heald also managed to survive. He was wounded twice, while his wife was wounded seven times.

They were eventually turned over to a British commander at Mackinac who then sent them to Detroit. There, they were exchanged with the Americans.

The rest of the survivors were taken prisoner. They were not treated well, and many died as they were moved about. Some of them were sold to British soldiers as slaves, although they were soon released. The bodies of those who died were left where they were for the animals and the elements to eventually erase.

The fort itself was set on fire. The Indians celebrated their victory as the logs and other remnants of the fort burned. Replacement troops eventually arrived at Fort Dearborn's location a year later. They found the ground burned and dozens of skeletons scattered about the remains. The soldiers buried what bones were left and rebuilt the fort, which was eventually abandoned for the last time in 1836.

SOME REALLY BAD PEOPLE

Throughout the history of this country, there have been some notoriously bad people. Some of them have even formed groups that have done horrible things together. Very few, however, have been as bad or notorious as the Harpes.

This rather strange family committed a string of murders and wreaked terror across the country in the late

1700s. The spree stretched from Virginia to southeastern Illinois and ultimately took the lives of forty men, women and children. All of it began with two men who called themselves brothers—Micajah and Wiley Harpe. To most at the time, however, they were simply known as Big and Little Harpe.

The spree actually started in Tennessee in the summer of 1795. The Harpes were living on a farm just outside of Knoxville. They were accused, justly, by a neighbor of stealing horses. The Harpes ran, with the neighbor in hot pursuit. The Harpes got away, but they didn't go into hiding. Instead, they visited a bar near Knoxville that was known for its fights.

Inside the bar, they found a man who, to history, is known only as Johnson. Whether justly or not, the Harpes believed that he was the man who had informed their neighbor of their horse-stealing activities. The Harpes killed him and left his body floating in a nearby river.

This started the pursuit that would send the Harpes across the country with their mysterious wives, killing as they went. On their way out of Tennessee, heading east to meet up with their wives, they killed a couple of travelers from Maryland and then a young man from Virginia. They didn't dispose of the bodies properly, and this only increased the number of people pursuing them.

The Harpes eventually made their way to Kentucky. While there, they committed so many crimes and wreaked

such havoc that the governor issued a $300 reward for their capture. Once again, the Harpes were forced to flee. Eventually, they made their way to Illinois, where many historians believe they spent only a few weeks. However, during that time they murdered three or four people.

The Harpes were headed for Cave-in-Rock, where there were bands of pirates living and operating, raiding travelers along the rivers there. While on their way to the cave, they murdered two or three people in cold blood, shooting them down in the road and setting fires. When they reached the cave, they joined the band of pirates, but soon the pirates found that they were too rowdy even for their standards.

The Harpes continued for a while, moving from southern Illinois to Kentucky and back again, bringing terror and mayhem wherever they went. They showed no remorse for killing women and children. They killed in order to steal, but they sometimes killed just for the sake of killing.

Eventually, the people looking for them caught up with them. Spies were dispatched and soon tracked down Big and Little Harpe. They caught up with Big first, as he was riding away, and called for him to surrender. He ignored the pleas and tried to run. He was shot in the leg and then in the back. With his spine damaged, he attempted to keep riding but eventually fell to the ground and was quickly surrounded by a posse. One of his victims was among the posse, a man whose entire family had been

murdered by the Harpes. He took his knife and cut off Big Harpes's head as the outlaw lay bleeding.

Little Harpe rejoined the pirates at Cave-in-Rock and continued for another few years as a pirate. Eventually, however, the reward on his head was too tempting for his pirate friends. They turned on him, killed him and brought in his head to the authorities for a reward.

The Harpe women were eventually split up and sent to different areas of the country, along with their

children. The Harpes' reign of terror had ended, but the memories still live on in some areas of southern Illinois.

THE STRANGE MOUNDS OF CAHOKIA

Long before people with names like Marquette and Joliet were documenting the land and rivers in and around Illinois, there were busy and bustling Native American tribes living in the area. By the rather arrogant Europeans, these tribes were seen as "savage" and "uncivilized." It was assumed that these tribes did not have the capacity to form major cities or build anything of great stature or importance.

It was with some surprise that early explorers began documenting the huge mounds in and around Illinois and the Midwest. At first, these were thought to be geological formations. Then, as archaeologists began looking more closely at them, they discovered that these were man-made structures. They were often used, so they found, for burials and therefore served a purpose much like that of the Egyptian pyramids.

At first, the early experts thought that the mounds were created by ancient ancestors of the Native American tribes. They began studying the bones and skulls and comparing them to Native Americans who had died only recently. The discovery was shocking. They found

out that the Native Americans alive today were the same ones who had created these structures.

One of the largest collections they found was near what would become the city of St. Louis, just across the great Mississippi River from Illinois. No one knows what the Native American name for the city they found there was, but today it has become known as the Cahokia Mounds.

One of the largest of the mounds ever discovered is located there. It is known as Monk's Mound because it was discovered by Trappist monks farming in the area. It is a stepped pyramid that covers sixteen acres of land. At the top of the huge mound, explorers found the remnants of what appears to have been a temple.

As explorers investigated the area around the mound, they made a shocking discovery. It was not just a village that had been located here but something equivalent to a major city. During the era of the Middle Ages, the city now known as Cahokia had more people than London. In fact, it is believed that twenty thousand people were living there at that time.

There were more than 120 mounds in Cahokia. The locations of 106 of those mounds have been documented. Many were destroyed by weather and sometimes by men as they used the land for farming and development. The area was named Cahokia after a tribe of Illiniwek Indians who were living in the area when the French arrived in the 1600s.

The entire city was probably surrounded by a wooden stockade fence. The mounds were for important buildings and temples, as well as for burial purposes. There was also found nearby an area of wooden posts driven into the ground. This has become known as Woodhenge, and it is believed that the Native Americans used it to monitor the movements of the sun. The posts line up perfectly with where the sun rises and sets during the course of a year.

Cahokia Mounds is now a tourist attraction, and people can climb the huge mound. There is a museum there as well. There is also still a mystery. What happened to the city? No one knows for sure.

Some have suggested that the city may have been a thriving metropolis through the 1300s before slowly

declining and becoming entirely abandoned by the 1500s. Some have suggested that overcrowding was to blame. Others have suggested that civilization and order may have just broken down in the city itself, causing residents to eventually move away. But these are all just theories.

Today, there are only huge mounds and strange artifacts left behind. Some say the place is haunted, and some say it is still filled with power.

THE CURSE OF KASKASKIA, ILLINOIS

Before Chicago emerged as the major metropolis in the state of Illinois, there were other cities vying for the title. It often had to do with what form of transportation was dominant at the time. At one time, the biggest method for transporting goods and people was the Mississippi River. Therefore, with the river running the length of Illinois' western edge, cities along the river were some of the state's biggest and most populated centers.

This was true of a city along the western edge of the state, located near Missouri and known as Kaskaskia. It was founded in 1703 by the French, who used Illinois as a major supplier to their fur trade. Kaskaskia was located right on the river and had a prime location for those wanting to travel up and down the waterway's length.

The city soon began to grow. Before Illinois became a state (1818), Kaskaskia was the territorial capital for the entire region. The city itself stuck out like a tiny finger into the Mississippi River. The population began to explode, and buildings began to pop up along the finger peninsula.

In 1820, the State of Illinois decided that it would be better to find a capital somewhere more centrally located. Despite the growth that the city of Kaskaskia was experiencing, the decision was made to move the capital to Vandalia. Kaskaskia was still a major city, however, and everyone assumed that it would continue to grow, even without its state capital status. Sadly, that did not happen.

Many believe that the city was cursed. According to legend, a young Indian hired by a local Kaskaskia man named Bernard fell in love with the man's daughter. When Bernard did not approve of the match, the young Indian was driven off. He returned, and he and Bernard's daughter attempted to escape together. Legend says that Bernard tracked them down, tied the young man to a huge log and set him adrift in the river. The young Native American reportedly cursed Bernard and the town, saying that Bernard would be dead, he and Bernard's daughter would be reunited and Kaskaskia would be destroyed.

Whether any of that is true, in 1881 a flood hit the town of Kaskaskia. So huge was this flood that it changed the

course of the Mississippi River. Rather than running to the west of the town, it now ran to the east of the town, cutting off the peninsula that connected Kaskaskia to Illinois. The town was now only accessible via an ancient bridge that could only be reached by the Missouri side. Kaskaskia had become an island.

The population began to leave in droves. Farms and homes were taken by the ever encroaching river. The

church was built and rebuilt, but each time the waters would find it and tear it down. The town's cemetery was hit with floodwaters, causing coffins to rise to the surface before sinking beneath the waters and washing downriver.

The town has since been flooded many times. In 1993, the entire island was nearly completely covered, and it was feared that it was gone for good. The town came back, but a 2000 census showed that only nine people lived on the tiny island, and there were only a few buildings left standing.

Illinois' capital was eventually moved to Springfield. Vandalia did not suffer the same fate as Kaskaskia.

The Horrors of Hickory Hill

According to legends and local folklore, one of the most haunted places in Illinois is an old house on the Saline River in southern Illinois. Even without the tales of ghosts and hauntings, the things that went on in this house are likely to chill anyone to the bone. This house was the only place in Illinois where slavery existed and was routinely practiced, even though Illinois did not allow slavery within its borders.

The man who built the house known as Hickory Hill was John Hart Crenshaw. He was actually quite prominent and well known in Illinois at one time. He

made a fortune manning a salt mine located in a large salt deposit in southern Illinois.

Back then, salt was a key mineral used by nearly everyone; in fact, it was so important that it was often used as currency or as a bartering agent among traders and consumers. Salt was key in preserving food long before refrigeration was something anyone knew about.

Illinois had long ago banned slavery. In fact, when it became a state, the banning of slavery was written into the state constitution. However, there were exceptions. Because the salt mines were so important to the state economy at one point, it was acceptable and legal to lease slaves from southern plantations for upward of a year to work in the mines.

Crenshaw took advantage of this, but he went above and beyond and began kidnapping freed slaves and forcing them to work for him in his salt mines. He hired men, known as "night riders," to search out slaves, both freed and enslaved, to bring them to work for him. When he was through, or if he needed some extra income, he could also sell them back to southern plantation owners, creating a kind of reverse underground railroad.

Crenshaw had a large estate. Upon that estate, he built a huge, elaborate and elegant house. The grand columns, which were in style for the wealthy in those days, were visible from the outside. What was not visible from the outside were the modifications he made to allow him to keep slaves for his mine.

Crenshaw, by that time, was vastly wealthy and hugely influential in the state. He made so much money that one year, one-seventh of the income taxes collected in the state of Illinois came from him. He had the power and influence to get away with what he had planned for some time.

He built a huge pathway that led from his house down to the Saline River. This allowed slaves to be transported by boat and enter into the house without anyone seeing. He also built a path into the rear of the house that was large enough for a carriage to travel right into the house itself. This was another method by which he could bring slaves into the house without being seen by anyone who might be passing by.

The real horrors of the house, however, were located in the attic on the third floor. This attic is still there today. To reach it, you have to climb a very worn and narrow set of wooden stairs. These stairs lead into a hallway that leads straight down to a small window at the far end. On either side of the hallway are small cell-like rooms. In each of those cells is a small wooden bunk nailed into the far wall, facing the hallway. The rooms are bigger now than they were, but even so, a grown man can barely turn around inside one of the cells. At one time, the cells were even smaller. During the summer months, the heat in the attic would become unbearable, with the small window at the far end of the hall providing the only light and ventilation. The prisoners or slaves were chained to the

wall via thick metal rings and wore heavy balls attached to their legs.

No one knows how many men and women might have lived for a time in these inhumane conditions. No one knows how many may have died from the dangerous and backbreaking work in the salt mine or from the conditions in the attic. However many there were, Crenshaw was able to run his illegal slave trade for some time—at least until 1842.

Crenshaw was indicted for kidnapping a free black woman and her children. Once he was indicted, the rumors about his operations began to spread. His business soon began to decline. Not only did people not want to do business with him because of his crimes, but also salt deposits in other parts of the rapidly expanding country were found to be better suited for salt production than the mines in Illinois.

The final blow came when Crenshaw lost a leg. He was reportedly beating a woman who was working in his fields. Another slave attacked him with an axe and took off his leg. His holdings were eventually sold off, and his fortunes vanished. He eventually sold Hickory Hills and moved away. He survived for a while by investing in a wide variety of businesses and eventually died in 1871.

The house has stood where it was built since then. It was owned for a long time by the Sisk family. However, rumors began to spread that the attic was so haunted

that no one could spend the night there. This has proved largely true, with even the toughest men running screaming into the night.

These days, the house is owned by the state. It is closed to public display at this point, but rumors persist that the state intends to turn it into a museum and historical landmark. It remains a blemish on the face of Illinois, but it is also a part of the state's history.

THE ATTEMPT TO STEAL LINCOLN

From the time Abraham Lincoln was assassinated and buried in a cemetery tomb in Springfield, Illinois, there were rumors that plotters were planning to steal his corpse. Given how Lincoln had been both beloved and hated by much of the country, it is surprising that more was not done to guard his body. Although entombed in a crypt, it was not entombed in such a way that someone with determination and the resources couldn't steal the coffin and the corpse inside.

Springfield was like a lot of cities in Illinois. It had a good part of town and a bad part of town. In the bad part of town, there was a man named James "Big Jim" Kinealy, an Irishman with a penchant for doing bad things. He was the operator of one of the largest counterfeiting operations in the country at the time.

Kinealy ran into some trouble in 1875, when his prized engraver, Benjamin Boyd, was arrested. Without Boyd, his counterfeiting operation was in serious trouble. Both the money he had earned from crime and the fake money began to dwindle. He began to look around for a way to make money fast. The idea of stealing the beloved former president and ransoming his body came to mind.

His first attempt was a disaster. He began recruiting people to help him. Being a relatively smart criminal, he tried to distance himself from the crime itself and bring in other people to do the dirty work. He recruited a man named Thomas Sharp, who in turn began searching for more people to bring into the scheme.

Sharp and the men he recruited began to make their plans. Kinealy, meanwhile, went to St. Louis to work at a livery stable he operated there. This gave him the perfect alibi.

Sharp and his men befriended a man named John Carroll Power, who was a guard at the tomb of Lincoln. Power gave tours of the tomb and was known for his friendliness. Sharp and his men posed as tourists and began asking him questions. Soon, they found that there was no guard at the tomb at night.

Sharp, however, liked to drink, and he liked to talk. After cementing his plans, he spent the night at a local brothel he liked to attend. He got drunk and began talking about his plan to the madam who operated the brothel. The next day, Sharp headed out of town

on business, and when he returned, he found the entire town buzzing about a plot to steal Lincoln's body. The plan was scrapped, and Kinealy returned to Springfield to try and find more competent people to work with.

Power had heard the rumors and was very upset. He tried to convince his bosses that they should increase security. However, his bosses thought a plot to steal the body was too far-fetched, and they ignored his pleas.

Kinealy, meanwhile, made his way to Chicago, where he became the owner and proprietor of a bar known as the Hub. He still had the idea of stealing Lincoln's body and holding it for ransom. He began using people who worked for him at the pub to start recruiting a new crew of people. It took time to find the necessary people and then more time to plan the heist.

The plan was to sneak into the tomb under the cover of darkness. The men had scouted the tomb before trying to make the heist. Once the body was stolen, one of their crew would pose as an innocent bystander forced to participate and negotiate with authorities for the return of the body.

Come November, they decided to put their plan into action. The night was reportedly dark and without a moon as they snuck into the cemetery. Right away, though, things started to go wrong. They found the door locked, not with a simple lock, but with one that was much thicker than anticipated. One of the men broke

the saw blade trying to cut through the thick lock. This required their locksmith to try filing his way through, a process that took much longer.

What the crew didn't know was that those assembled still had not been able to keep their mouths shut. A team of Secret Service agents was actually watching the tomb as the men were busy trying to file their way through the heavy lock. In fact, the agents had managed to recruit one of the members of the crew to their side. He was supposed to come outside and light a cigarette once all of the men were inside the tomb as a signal for the agents to move in.

Eventually, the lock was filed away. The crew entered the tomb and found that the covering of the tomb was so huge and heavy that it proved almost impossible to move. The man recruited by the agents was asked to assist, almost preventing him from giving his signal. Finally, the men managed to remove the huge marble lid.

Once removed, the recruited man stepped outside and lit his cigarette. The agents moved in and found the coffin without its lid, but the men were gone. While the one man had stepped outside to have a cigarette, the others had gone out another exit to catch some air.

The men taking a break heard commotion inside the tomb as the agents searched for them. They ran. They got away, but the member of their crew who had been recruited by the Secret Service was still giving the feds information. Eventually, two men named Mullen and Hughes were arrested.

Robert Lincoln, one of the former president's living relatives, hired some of the best lawyers in the state to try and get the maximum sentence for the potential thieves. However, this act wasn't enough, and the two men were convicted for conspiring to try and steal the coffin, which had a value of about seventy-five dollars. Hughes and Mullen were each given one year in Joliet Penitentiary.

Lincoln's corpse was moved several times after that. Finally, today's tomb was built. In 1901, the coffin was placed in a special vault designed by Robert Lincoln himself. The coffin is ten feet beneath the floor in a steel cage. The steel cage is covered with tons of concrete and dirt. To get to the coffin now would take dynamite.

ILLINOIS' ATLANTA AND THE MOTHER ROAD

The famous Route 66 runs through much of Illinois. Known as the Mother Road, the route actually starts right in downtown Chicago. It is said that the start of Route 66 is guarded by the statues of lions located on either side of the stairs leading up to the Art Institute in downtown Chicago. The road then travels south before heading west through Missouri.

Route 66 passes through a number of small towns and interesting cities. At one time, they were loaded with unique sites and attractions for motorists. These days,

much of Route 66 is major highway. However, the town of Atlanta, Illinois, is still there, and much of the town is dedicated to Route 66 and the unique things that were located in Illinois on that road.

The town of Atlanta began its life as Newcastle in the year 1854. However, after Newcastle was created, the railroad was built through Illinois and the town found itself too far from the tracks. To remedy this, the entire town was picked up and moved. When it resettled, it was renamed Atlanta.

A wooden grain elevator was built in Atlanta to serve the farmers in and around the area. J.H. Hawes Elevator continued to operate until 1976. The elevator, made entirely of wood, is still standing and is now on the National Register of Historic Places. Beneath the elevator in the building located there is a museum that shows tourists how horse-drawn wagons were unloaded and then loaded onto grain trucks.

Atlanta is also famous for being the geographic center of the state of Illinois. There is a second museum located in the center of downtown in part of the Atlanta Public Library and Clock Tower. This building is also on the National Register of Historic Places. In 1973, a museum was built to house relics and historical pieces from the town itself.

In the downtown area of Atlanta, there is a park dedicated to Route 66. This park houses another famous Illinois relic, known as the Hotdog Man. This statue,

roughly nineteen feet high, used to stand outside Bunyon's Hotdog Stand in Cicero, Illinois. When the stand was closed, the statue was placed by the family in the park in Atlanta. These days, the statue is known as "Tall Paul" and has undergone extensive renovation.

Cruising through Atlanta is like taking a trip back through time. The town is lined with murals painted on one historic building after another. There is a country market that has long served a mom-and-pop grocery store. The town is also littered with other historic landmarks, such as the Carriage Shed, where Abraham Lincoln once stayed with a family called Hoblit. There is another Lincoln site known as Turner's Grove and a place called Gold Springs, which used to be a major resort and vacation spot.

The historic road and the historic town hold tight to the traditions and history of the state of Illinois. While the rest of the state looks like any other town you might find anywhere else in the country, the town of Atlanta has gone out of its way to stay unique, while still retaining its small-town values.

STRANGE HAPPENINGS IN THE TOWN OF WATSEKA

The town of Watseka is located in the northeastern portion of the state, very close to the border of Indiana

and not far from the city of Chicago. It is not a terribly big town, and it certainly wasn't much bigger back in 1877, when some very strange things happened. Actually, before the story of Lurancy Vennum was finished, it was revealed that this was the second occurrence of strange happenings in the small town.

The story actually starts with a young girl named Mary Roff. Mary was born in 1846, and soon after her birth, she began having terrible seizures. At the age of six months, she was regularly experiencing tremendous and terrifying fits in her crib. As she grew older, these seizures grew worse, and she began complaining of hearing voices in her head. She said that the voices came from nowhere and were telling her to do things she knew she was not supposed to do.

As Mary got older, the seizures and the voices got worse. The Roff family tried to find help for her. She was declared insane, and they were told to have her committed. Back then, however, asylums were not places where the insane were sent to be cured. The supposed "cures" were little more than torture. The asylums were essentially kennels to keep the insane away from the rest of society.

When she had seizures, Mary would sometimes fall into trances. She would speak in voices that were not her own. She had knowledge of things and places that she should have known nothing about. She said she was able to speak and hear people who were dead.

Mary and her family tried to keep her at home for as long as they could. However, the voices got worse, and Mary became obsessed with blood. She became convinced that if she could drain the blood from her body, she could remove the voices. She stuck herself with pins and needles and even attached leeches to herself. Finally, she took a straight razor and cut herself up and down her arms. She was found lying in a pool of her own blood. Her family finally agreed to have her committed.

Mary did not survive much longer after that. She underwent some horrific treatments, such as ice water baths followed by submersion in scalding hot water. In July 1865, Mary's battle with her mental illness ended and she died.

Lurancy Vennum, meanwhile, was born in April 1864. When she was seven years old, she and her family moved to Watseka. This was long after the stories of Mary Roff had faded in the memories of most of the residents there. When the Vennums first moved into their new house, things seemed totally normal.

One morning—and it was a normal morning like so many others—Lurancy claimed that she did not feel well. She said she felt dizzy and nauseated. As she was telling her mother about how awful she was feeling, she collapsed and fell unconscious. She was out for the next five hours, completely unable to be awakened. However, when she woke up five hours later, she said she felt fine and normal.

The next day, however, Lurancy fell into another deep sleep. She lay absolutely still in the bed, and this time she began speaking. She started talking about visions and claimed that she was seeing spirits and having conversations with people that no one else could see. She said she was in heaven and could see and speak to spirits and ghosts, including that of her brother who had passed in 1874.

After awakening from the strange trance, she had no memory of what she had said. But the trances and strange behavior were only just beginning. Her visions soon became terrifying. She started to claim that the ghosts were chasing her through the house and calling her name. The spirits began visiting her a dozen or more times a day.

The Vennums were desperate to help their daughter. Her parents took her to doctors and they checked her out, looking for some physical reason why she would be having these experiences. They could find nothing. Finally, it was determined that Lurancy was insane and it was recommended that she be committed.

Word of Lurancy had started to spread in the small town. One family who heard about what was going on was the Roffs. Upon hearing that Lurancy was to be committed, Asa Roff, Mary's father, made the trip over to the Vennum house. Asa sat the parents down and told them the story of Mary. He then begged them not to commit Lurancy.

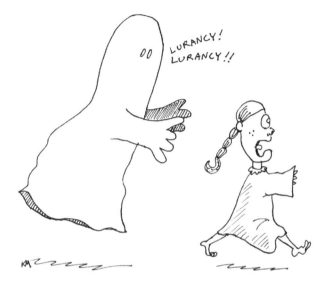

Mr. Roff brought in a man named Dr. E. Winchester Stevens. Dr. Stevens examined Lurancy, and he agreed with Roff that she was not insane. He also begged the Vennum family to let him try and help her. Roff and Stevens both thought that Lurancy was a medium who was able to speak to and see spirits.

Stevens put Lurancy under a hypnotic spell and tried to get her to become a vessel for the spirits. At first, a spirit claiming to be someone named Katrina Hogan

began speaking out of the little girl's mouth. After a few moments, a man named Willie Canning began speaking through her. He claimed to have killed himself years before. She spoke as Willie for over an hour. She then claimed that she was in heaven, surrounded by spirits, and she was going to let a gentle spirit enter her. That spirit, she said, was Mary Roff.

Lurancy seemed to awaken, but she claimed that she was still Mary Roff. This kind of trance continued for the rest of the night and into the next day. When she spoke, she claimed not to recognize either the Vennum house or anyone in the Vennum family. She told the Roffs that she wanted to go home. The news of this soon spread, and Mary Roff's mother left her house to come and see Lurancy for herself. She brought Mary's sister, Minerva, with her, and as they approached, Lurancy—or Mary—looked out the window and said, "Here comes Ma and Nervie." No one other than Mary called Minerva by that nickname.

Lurancy looked like Lurancy but still claimed to be Mary. She reacted to the Roffs with affection but treated the Vennums politely, as if they were strangers. Needless to say, Lurancy's parents were stunned and disturbed by this, but they agreed to let Lurancy/Mary go back to the Roff home.

As the Roff family, with Lurancy Vennum in the buggy beside them, passed the location where they had lived while Mary was alive, Lurancy/Mary expressed

her dismay. Why were they driving past the house? Why weren't they going to the home she knew? Once again, they were convinced that Mary had taken control of Lurancy's body.

For the next several months, Lurancy lived at the Roff home. It was as if all traces of Lurancy Vennum were gone. She seemed to not remember her life as Lurancy but recalled everything about the Roff family. She treated them like her family. She continued to be polite to the Vennums, treating them like friends.

Lurancy stated that she would stay with the Roffs until sometime in May. She spoke to the Roffs as if she were Mary. She recognized things that had been Mary's and had never been seen by anyone else, certainly not by the Vennums. She spoke to neighbors and friends of the Roff family and seemed to recognize them, though they were people Lurancy did not and could not have known.

Rumors began to spread about Lurancy. Many felt that she was not really possessed by Mary but was being controlled by Dr. Stevens and Mr. Roff. Several people, including the Vennums' pastor, begged all involved to have Lurancy committed. They did not, however, and Lurancy continued to behave as though she were Mary.

May finally arrived. Mary/Lurancy became sad. She began hugging and holding on tight to her mother and father. She said it was almost time for her to go. She knew that Lurancy would go back to her family and she would have to leave. As the month dragged on,

her moments of weeping increased. Then, suddenly and without warning, Lurancy opened her eyes and was no longer Mary.

By the end of the month, Lurancy had returned to her family. She experienced no more of the strange seizures or symptoms that she had before. Her family claimed that she had been cured by the intervention of Mary's spirit. Lurancy's health slowly came back, and she went on to live a very normal life.

To this day, no one knows for sure what happened to Lurancy Vennum. The people of Watseka have always been divided about it—at least, those who still remember her. Life returned to normal, and Lurancy and her strange behavior faded into history.

The Strange Case of Lieutenant Governor A.F. Hubbard

The state of Illinois has become rather famous for the corruption of the office of governor. However, whatever things the governors have done, there has never been a case quite as strange as what happened with Lieutenant Governor A.F. Hubbard, who was in office in the late 1800s under the leadership of Illinois governor Edward Coles. Hubbard was a very convincing man, to say the least, and his attempt to

gain control of the state is a seldom-heard story among those who live in Illinois to this day.

Hubbard fancied himself a lawyer. He was known for his very convincing oratory in the courtroom in trying cases that were not before a jury. In one case, he managed to win simply by declaring that the man at the other table was a "Yankee" and couldn't possibly know what he was talking about.

His ambitions were high. He thought he was smart enough to become governor. He may have even had ambitions beyond that, but his attempt to seize control of the governorship put a stop to whatever aspirations he may have had.

Hubbard insinuated himself into the orbit of Governor Coles. He felt that he was entitled to a certain position in the government and proceeded to annoy the hell out of the governor until the man wrote a letter on his behalf. When the position was not forthcoming, he began to believe that the letter had not been entirely favorable to him.

Hubbard was a patient man. He managed to become lieutenant governor, second in line should the governor not be able to fulfill his duties. He kept an eye on things, waiting for a time when he could try to get his revenge. He thought he had found his time in 1825, when Governor Coles told him he had to go out of state for a while once July ended. Coles wanted Hubbard to step in and make sure everything ran all right in his absence. Hubbard readily agreed.

Hubbard moved himself into the governor's office and immediately began performing the duties of governor. When Coles finally returned from his trip, he found Hubbard unwilling to remove himself from his office. Hubbard had been part of the Illinois Constitutional Convention, and he invoked a portion that stated that if the governor is unable to perform his duties for any reason, the lieutenant governor would be put in charge. Hubbard claimed that when Coles left the state he was, essentially, relinquishing his position, and this made Hubbard the new governor.

Hubbard managed to find a few others who were on his side. He believed he now had the right number of people to back his move. He decided that it was time to try his position in the state courts. He put on his lawyer hat again and argued his position, only to find that the courts were less than receptive to his claims.

By now, news of the attempted "coup" had spread throughout the state. Hubbard believed that his support base, even among the people, was growing. He decided to plead his case to the state legislature. He found only one member in each house who was in favor of his petition and met defeat again.

Still not satisfied, Hubbard soon declared that he would run for the governor's office in the next election. He had been governor for ten days and felt that meant he could run for reelection. He believed he had enough support among the people to put Coles out of office

and take over the state. He traveled around the state and made speeches, beseeching the people to elect him, making use of the oratory skills he had mastered as a lawyer.

The election came, and Hubbard awaited what he was sure would be a victory. He was shocked to find that he had only received 580 votes. His performance in the election was so poor that he soon realized he was not nearly as popular as he had thought. He subsequently vanished from public life.

What happened to Adolphus Hubbard after that is not recorded in the history books. However, those

who study Illinois politics still shake their heads in disbelief at the story of the lieutenant governor who tried to take over the state when the governor left the state on business.

Healing Waters in the Original Springs Hotel

There was a time when people went to spas for vacations to partake of the "healing waters" located on the property. These springs were normally filled with minerals—in particular, iron, which was thought to be a great cure for many ailments, including arthritis. While most people probably think of places like Hot Springs, Arkansas, as the most famous of the mineral springs, or the resort where Franklin Delano Roosevelt liked to spend his time, there was, and still is, an active mineral spring in southern Illinois known, these days, as the Original Springs Hotel and Baths.

The hotel and the springs are located in a small town called Okawville, and the springs themselves were discovered entirely by accident. A man named Rudolph Plegge simply wanted to dig a well on his property to help with his harness and saddle shop. He dug down and was delighted to find water beneath the earth. However, he was dismayed when the metal

pots he was using to carry the water developed leaks after a short period of time. He soon switched to using copper kettles instead of tin ones, and those began to leak as well. He wanted answers.

A man named Dr. James McIlwain stepped forward and said he could test the water. When he did, he discovered a very high mineral content. A man named August Schultze, who was part owner of a business across the street from the saddle and harness shop, put up some money for a more extensive test of the water. The water was bottled and sent to St. Louis, where it was discovered that it had eight different minerals, with the highest content being iron. The iron and mineral contents were close to those recorded in the Carlsbad Baths in Germany and the more famous Hot Springs in Arkansas. The one difference was that the water in Illinois was cold instead of hot when it came out of the earth.

Dr. McIlwain decided that it would be a good idea to test the waters on one of his rheumatic patients. This patient was not responding to any of the other treatments he was prescribing. The man came and bathed in the mineral springs and soon reported that he was completely cured.

Plegge got in touch with someone he knew who had once worked at the Carlsbad Baths. They soon realized that they had a money-making possibility here that went beyond the saddle and harness shop. They began

advertising locally, and soon they were doing a brisk business among the local residents, who were partaking of the baths.

They were limited at that time by the remote location of the town and the difficulty in getting there from the larger city of St. Louis, which was the closest metropolitan area. There was also no place for bathers to stay, and the local boardinghouses were taxed to capacity when the railroad finally made the town more accessible. Plegge had dreams of building a three-story brick hotel near the springs and even started the process of putting in a foundation in 1875, but it never materialized.

Plegge sold the spring to a group of people from St. Louis. The wife of Reverend J.F. Schierbuam had come to the springs when all other treatments to heal the ailments that had made her a virtual invalid failed. She proclaimed the waters a miracle cure and convinced her husband and several members of the congregation to buy the property from Plegge.

The sale was made, and immediately plans for a hotel were drawn up. The original idea was for the hotel to be made of brick and to be a very fancy and grand building. There was to be a huge world-class kitchen and forty-six rooms. Construction began, but it turned out that the bricks were too expensive, and the hotel was built from wood instead.

The new hotel was dedicated and opened to much fanfare in May 1885. It was a huge success. People began

arriving from all over the area to enjoy the healing waters that flowed beneath Okawville. After only one season, it became obvious that the good reverend would have to expand his operations to meet demand. When the season ended at the end of the summer, plans were made to expand the hotel.

A new bathhouse was also built. During the construction of the new bathhouse, a threshing machine engine that had been purchased to help provide power for the hotel exploded. Several people were hurt and one died, becoming the first person to die on the property.

The town began to prosper. More stores were opened. Buses were created, drawn by horses, to ferry people from the train station to the hotel. A recreation area known as City Park was opened where people could dance their nights away.

Soon, others decided to dig below ground to find what was there. Before long, the Original Springs Hotel had competition. The Washington Mineral Springs were found, and a man named Gottlieb Roth opened his bathhouse and made plans to build his own hotel.

Eventually, a man named J.W. Schreiner bought the Original Springs Hotel. He was originally from Minnesota and had made the long journey upon hearing about the healing water. He had partaken of the mineral springs and felt that they had helped him with his ailments. He took over and began expanding further.

In 1890, the hotel had given nine thousand baths. The hope was to exceed that amount in 1891. The bathhouse was enlarged to double its capacity. However, that November a fire swept through the new building. It was blamed on an exploding lamp, but some still wonder if arson or industrial sabotage might have been

the real culprit. Some say that there were those who held a grudge against the previous owners and didn't realize that someone else owned the property when they sought revenge.

The Schreiner brothers began making hasty preparations for the next season. They just barely made it, and a grand celebration was planned for the reopening the following season. The entire town was relieved, and the next season was a huge hit. The hotel was constantly sold out, and those who had extra rooms in town soon began selling and renting them as well.

The fire helped out the competition, however. The Washington Springs Hotel began to boom. Like the Original Springs Hotel, it offered more than just the baths and a bar; it also built a private amusement park for guests. It offered boating, fishing and dancing. It encouraged further building in town to provide entertainment for guests. An opera house, ice cream parlor and the Rex Theatre were constructed.

The Washington Springs Hotel was the first to put in electric lights. The Original Springs Hotel, not to be outdone, also added electric lights. It installed more lights than the Washington. It soon had a large enough generator that it was able to lease electricity to Okawville. Soon, lights began to illuminate the downtown area.

The Washington Springs Hotel began bottling water and shipping it around the country in 1898, a novel new concept for the time. The Original Springs Hotel began

doing the same thing and would continue to sell its water until the 1980s.

In the midst of the success, however, tragedy struck. Alex Morgan, one of the owners of the Washington Springs Hotel, was meeting some potential business partners at the train station when he made a wrong move and stepped in front of a speeding train. He was killed instantly, shocking the entire town.

Over the years, the hotels changed ownership, expanded and contracted. The crowds seemed never to wane, and the demand for the mineral springs seemed to grow with each season. Tragedies and strange tales continued to plague the hotels.

In 1911, the owner of the Original Springs Hotel, Anna Schierbaum, died. Her son, Ben, took over operations. He married a woman named Alma Schulze, the daughter of the man who operated a store across from the hotel. According to legend, their marriage was rocky and very unhappy. Alma eventually left Ben when the hotel closed for the season in 1916. Ben spent days searching for her. She had left no note, and no one seemed to have a clue where she went. Eventually, he gave up and was seen heading back to the hotel. Days later, he was found by a traveling salesman looking to book a room. He was lying on the floor with a double-barreled shotgun on his lap and most of his head missing.

There were constant plans to keep expanding the hotels. It looked like the luck would never run out.

Then the Great Depression hit. Both hotels ran into problems. The weekends were almost always sold out, but during the week the hotels were usually empty. Both hotels changed hands numerous times and managed to survive the economic crisis that nearly crippled the country.

The Original Springs Hotel may have been a hideout for several notorious Illinois gangsters as well. It is known that Charlie Birger and the Shelton brothers used the hotel for meetings. Charlie Birger's territory was in the southeastern portion of the state, and the Shelton brothers were based out of east St. Louis, so the hotel was a perfect middle ground for them to meet.

For a while, the Original Springs Health Resort was in existence. The hotel became a country club, and memberships sold for $100. It did well, but not well enough to cover expenses, so it reverted back to a general public hotel the following season.

Modern amenities were finally added to the Original Springs. Rooms were designed to have toilets and sinks, and some had their own showers. As advances in technology came into being, the hotels were often slow to adopt them. Ownership continued to change hands, and eventually Robert and John Schrage took control of the Original Springs in 1976.

The Washington Springs did not fare as well. It eventually closed, leaving only the Original Springs to

cater to those looking for a way to spoil themselves. The Boiler Room Lounge and Restaurant was added and opened to the general public in 1965. It remains open today.

Another fire hit the old hotel in 1988. The firefighters caused additional damage by breaking through roofs and windows to fight the fire. Some $400,000 worth of damage was done to the hotel. It was cleaned and reopened in a few weeks. Some of the rooms were enlarged and now had room for larger beds, as well as televisions and additional furniture.

These days, the Original Springs Hotel is still in existence. People still come from all over the country and the world to partake of the mineral-rich waters that flow beneath the property. It is like stepping back in time.

Ghost stories proliferate the hotel. Some say that a woman in a white period dress wanders the halls. Others say that there is a constant feeling of being watched, and some claim that they hear voices, feel cold spots or glimpse strange balls of light.

Whether you are attracted by the healing waters and the modern-day spa, the finer food offered in the Boiler Room Lounge and Restaurant or the myriad ghost stories, the Original Springs Hotel in Okawville is worth a visit.

THE MYSTERIOUS HEALER KNOWN AS
ANNA BIXBY

The woman who has become famous in Illinois history as Anna Bixby, or Bigsby, was born in the 1800s in southern Illinois. She was known to have talents as a healer and was popular among women and families as a midwife. More than likely, however, she had very little formal training and certainly no formal medical training. Of course, back then, in some of the smaller towns, it was not uncommon to find the medical needs being attended to by women or "healers."

The first thing that Anna did to make her famous was discover the cure for a disease that was ravaging the area. She had studied herbs and healing and was widely traveled. She came to Illinois, most likely from Tennessee, with her husband, Isaac Hobbs. When she arrived, she soon discovered that a strange illness was killing not only the people she was tending to but also the cattle. She immediately began to suspect that the cattle were eating something on the farms, and this was getting into the meat or milk being consumed.

She worked for weeks and then months, trying everything she knew, but nothing seemed to stop the disease. Person after person and cow after cow was dying. Entire herds of cattle were wiped out with amazing speed. The paranoid and superstitious townspeople began to spread rumors that a witch was spreading magic that was

causing the deaths. Anna refused to believe that this was the case. She studied the cows and the people and figured that the cows were passing it on through their milk. She observed that the milking cows were not getting sick, but anyone who drank the milk from them died.

Anna began spreading the word that people should avoid drinking milk. This warning did not find the cure, but it saved many lives. Anna instructed people to avoid the milk until after the first frost in autumn. She guessed that she had the winter to try and find the cure before the illness returned and started killing more people.

Anna set out that winter to find the cure, or the reason for the illness. When spring came and she was still searching, she headed into the woods and began studying the plants in the area. She was in the woods when she happened to meet a Native American known to the local farmers as Aunt Shawnee. Just like Anna, Aunt Shawnee studied herbs and traditional medicine. She pointed to a weed that we now call "milkweed" as the cause of the "milk sickness," as the disease had become known. The cows were eating this strange weed and passing it along in their milk, causing the illness.

Aunt Shawnee had seen the same thing happen among her people. Anna was grateful, and soon word began to spread that she had found the cure. People in town began wandering the woods destroying all vestiges of the plant. In 1928, years later, medical scholars finally acknowledged that Anna had found the cause of the problem and gave her the credit she deserved.

This story alone is enough to make Anna worth knowing about, but her story doesn't end there. Of course, the remainder of her tale is now couched in legend and lore, and what is true and what isn't is still up for debate. What is known is that Anna remarried at some point to a man named Eson Bixby. It is fairly well known that Eson was involved in a number of illegal activities.

According to one legend, Eson Bixby was involved with men such as John Murrell and James Ford who used Hardin County as a place for making illegal whiskey and for counterfeiting purposes. They used a place that, to this day, is known as Bixby Cave. Bixby reportedly took over all of those operations when the men who started them went to prison or were killed. Bixby also expanded the criminal operation by robbing people and stealing timber.

Anna was very old when she married Eson. It is believed that he was trying to steal her money by simply outliving her. When she turned out to be hardier than he hoped, he decided he was going to have to kill her. Legend says that he tied her with ropes and heavy chains and tossed her off of a bluff. It is then reported that she fell into a tree and escaped.

The only problem with this tale is that elements of it do not stand up to scrutiny. The area known as Bixby's Cave was just not big enough to handle a distillery and counterfeiting press. The cave had also been damaged when the New Madrid fault had an earthquake in 1811. So it was unlikely that Eson was running operations out of the cave.

More than likely, the account went something more like what the *Hardin County Independent* newspaper published in 1935. The writer of the article stated that a rider arrived at Anna's house during a fierce thunderstorm. He claimed that he needed Anna's abilities as a healer to assist a friend. Anna immediately got on the second horse and headed off into the fierce storm. The night was dark, and she was unaware who the person riding next to her was.

However, as Anna continued to ride next to the man, she kept trying to peer into his face. She finally got a clear view when a bolt of lightning lit up the sky. She was shocked to see that the man next to her was her husband. He noticed that she had recognized

him and he immediately stopped his horse and bound her hands.

Anna may have been old, but she was far from stupid. She immediately saw that he was planning to get rid of her. She began to panic. She started to run when she heard chains rattling as he pulled them out of his bag. She ran off into the woods, with the rain battering her and the lighting still flashing. She didn't know where she was, and as she ran she soon found herself falling off of a large drop. The ground literally disappeared beneath her feet.

As she fell, the ropes that bound her hands broke. She also broke several bones. She crawled to a fallen tree and hid behind it. She waited there, in the storm, as her husband came looking for her. She watched as he waved around a light in the pouring rain. Once he was done looking, Anna continued to crawl. By the time the sun came up, she had found a farmhouse she recognized. The people who lived there knew her and helped her after Anna told them her story.

Eson Bixby was eventually caught and imprisoned in Missouri. However, he managed to escape from prison and was never seen again.

Anna lived until the 1870s. When she died, she was buried next to her first husband. Her tombstone was inscribed only with the letter "A."

To this day, there are stories of her ghost still haunting the area known as Bixby Cave. She is also supposedly

seen wandering the woods as a glowing light. Whether any of this is true, of course, is anyone's guess. What is known is that a remarkable, self-taught woman once lived in Illinois, discovered the cure for a terrible disease and was nearly killed by her own husband before enacting a remarkable escape.

ZIEGLER, ILLINOIS

The Town that Was Almost the Nation's Capital

Of course, everyone knows that Washington, D.C., is the capital of the United States. It is hard to imagine any other city being the capital. At the very least, if anyone could think of another city as the capital it would likely be some city on the East Coast, like New York or Boston. Most would not think of a small town in Illinois.

Exactly how close the country came to moving the capital from Washington to tiny Ziegler, Illinois, is unclear. What is known is that, at the very least, the idea was considered, and had there not been a rather untimely death, it might have moved forward further than anyone today realizes.

In 1901, a man with millions of dollars named Levi Ziegler Leiter and his son, Joseph, bought up a huge amount of land in Franklin County, Illinois. They

purchased eight thousand acres and began plans to build a small town there. Joseph then sunk a coal mine and tapped into a vein of coal located on the property. The father and son soon formed the Ziegler Coal Company.

Joseph was a young man with big plans. He wanted his mine to be the largest and most modern coal mine the country had ever seen. He was so certain that his plans would come to fruition that when the first building was built on the property, he mixed champagne with the concrete to make up the cornerstone. To add to the festivities, he also threw a couple of diamond rings into the cornerstone. He carved the year 2004 on the stone as well because he was certain that his mine would be one hundred years ahead of its time.

By the time 1903 came around, Joseph began clearing the land around the mine. His father had powerful connections, including one that led right into Teddy Roosevelt's office in the White House. Joseph had a blank check to create whatever he wanted in his town, and he definitely took that to heart. His father knew people like Palmer Potter, Marshall Field and George Pullman, some of the wealthiest people in the country at the time and by far the richest people in Illinois.

Levi had made huge contributions to Roosevelt's campaign. When the town was about to be built, Levi decided to try and call in some favors with the young president. George Pullman had created an entire community around his railroad car factory, and Joseph

had a plan to do the same. However, he wanted his city to be better than Pullman's. Joseph hired the same architect who had designed the layout of Washington, D.C., to design his city.

At the same time, Joseph tried to appeal to Roosevelt's outdoorsman nature. The area around the newly laid out city was filled with deer, quail, ducks and even buffalo. He hoped that this would help convince the president that he would be more comfortable and much happier in Illinois than out east.

The design was conceived to be similar to Washington. It was envisioned as a circle, with streets radiating outward like spokes on a wheel. Joseph decided to honor his father by naming the town Ziegler, after his father's middle name. Soon, father and son began asking their wealthy friends to also start trying to influence the president.

The wheels were put into motion. The plan was to turn Ziegler into the nation's capital, complete with a new White House. In 1904, the first load of coal was brought to the surface. Ziegler was on its way, and things were looking positive in Washington as well. Joseph figured that it was nothing but onward and upward for him.

Unfortunately, like much in life, things did not work out as planned. The connections that Joseph had were due entirely to his father. The day after the mines opened with grand ceremony and celebration, his father died from a rare heart disease. Just like that, the blank checks stopped coming in, and his political clout was gone. He ran into almost immediate union problems with his mine, and the Ku Klux Klan began to hassle him over the labor he was using.

The labor disputes got so bad that threats were leveled against Joseph, who had publicly declared that his mines would always be union free. He had to protect his property, so he built a huge fence around his mine. He lined those fences with guard towers, mounted Gatling guns in the towers and gave the guards orders to shoot to kill anyone caught trespassing.

The town of Ziegler continued to grow, but not at the pace Joseph had originally envisioned. There was a large two-story office building at the very center of the circle. There was also a private home, a company store, schools, a hospital and land meant for churches. However, things were going from bad to worse for Joseph, and circumstances became even more dire after several explosions in his mine and further labor disputes. He finally pulled out of the business in 1910. He leased his holdings to the Bell and Zoller Coal Company and moved back to Chicago to find success in other endeavors.

The town of Ziegler thrived but never turned into the vast metropolitan area that was envisioned. The town reached its peak in population and technology in 1926, when there were seven thousand people living there. Thirty-five hundred were employees of the coal company, and there were 174 independent businesses in the town.

Ziegler was unique in that when the Great Depression hit, it was barely felt within the town limits. The Bank of Ziegler was given special permission from the government to print its own money with plates provided by the U.S. Mint. Huge amounts of money were flown in from St. Louis to keep the bank solvent and the town thriving.

However, things eventually turned against Ziegler. The world started to move away from coal dependency. The mine itself began drying up. Businesses soon began closing and moving away.

During World War II, Zielger sent a remarkable 450 men into the military. The town built an impressive memorial near the center of town to those who had fallen. However, the demand for coal continued to diminish. People began moving away as business continued to close.

Ziegler still exists, but today it has a population of only about seventeen hundred people. Most of the younger residents do not know how close their town came to becoming a major city and, more importantly, the capital of the nation. There is little left of the town that was, and the plans for the city to become the U.S. capital are long gone and forgotten.

THE WORST SEA DISASTER

In 1912, one of the biggest disasters the world had known up to that time happened in the Atlantic. The huge, supposedly unsinkable cruise ship HMS *Titanic* hit an iceberg and sank. It did not have enough lifeboats for the more than two thousand souls onboard. As such, over one thousand people died in the freezing water. The disaster was so shocking and horrifying that countries around the world made changes to how boats designed to carry passengers were maintained.

As a result of the *Titanic*'s sinking, huge ships were required to carry enough lifeboats to cart off every

passenger if the ship ran into trouble. This was a revolutionary idea at the time. Little did anyone know, however, that this new ruling would be, at least in part, responsible for the greatest sea disaster in United States history.

Lake Michigan is not truly served by the term "lake." It is a large body of water, and when you stand on the shores in Chicago, you cannot see the land across the way. It is, in effect, a large inland sea.

On this particular sea, commerce and passengers were ferried regularly. It was common to get on a boat and attempt to travel across the lake to reach cities on the other side. This was where the SS *Eastland* plied its trade as a ship that could be rented for excursion purposes.

The *Eastland* had some problems from the time it was built. Right from the start, those who piloted the ship stated that the boat was top heavy. The ship was likely to start listing to one side or the other, particularly if the boat encountered any kind of rough seas. Photos of the ship show that it sat very high in the water, with much of the boat and its several decks above sea level. After 1912, the *Eastland* had to add lifeboats.

On July 24, 1915, the *Eastland* was one of several boats that had been hired by the Western Electric Company to take its employees on a company picnic to Michigan City, Indiana. The Western Electric Company made electronic devices for an invention that was finally starting to catch on, to such an extent that one was in

every home. This invention was the telephone. Most of the workers were immigrants, several of whom did not speak English particularly well.

These were people who worked very hard and were close to their families. The Western Electric factory required workers to work long hours, putting together switches and fastening electronic parts, six days a week. To have an extra day off for something like a picnic was a novelty.

The SS *Eastland* got a very early start that morning. The ship was removed from its dock and built up a head of steam on its way to another dock on the Chicago River at 3:00 a.m. It was going to be a long day. The docks where it was supposed to pick up the Western Electric employees were located in Chicago and South Haven.

The ship arrived before 6:00 a.m. and the ballast tanks were emptied. These tanks were supposed to be used to balance out the ship as it filled with people and began to list from one side to another. However, the *Eastland* was notorious for its ballast tanks not working properly, and the system that transferred water from one side to another was dangerously slow.

Still, no one thought that anything was wrong. The employees began to arrive. They marveled at the tall ships towering over their heads as they walked down the streets to the dock. There were five ships, all meant to take the employees to Indiana. The first one in the row was the *Eastland*. By 6:30 a.m., there were nearly

five thousand employees lined up on the dock to get on the boats.

When the captain of the *Eastland* looked out his pilothouse windows, he saw the crowd and became a little concerned. He didn't want the crowd to get rowdy. So he made the decision to let the crew start admitting passengers. The gangplanks were extended toward the shore, and the ship was opened.

The passengers began to stream across the gangplanks onto the ship. Of course, there was no reason to stay on the side from which they had entered the ship. On that side were the docks. The other side of the ship had a view of the busy river. The passengers began to walk from the gangplank to the other side of the ship.

Soon, the railings along the river side of the ship were crowded. Some passengers began moving into the interior. They descended the stairs into an area where there was a bar, a piano and tables. For these passengers, this was the height of luxury.

The passengers were excited and happy, but the crew of the *Eastland* was starting to worry. A definite list toward the side of the river was starting to show. As more and more passengers entered the ship, the list became very noticeable. Even the harbor master, perched in his tower near one of the bridges, noticed the list.

The chief engineer of the *Eastland*, a man named Joseph Erickson, made a note of the list. He ordered the people working under him to stabilize the ship,

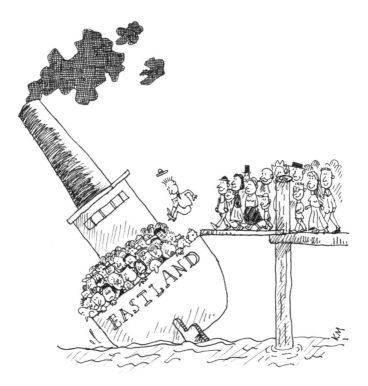

and they immediately set about trying to fill the ballast tanks on the side of the ship that faced the dock. The notoriously slow system, however, seemed to take forever. Slowly—agonizingly slowly—the ship righted itself in the water. By now, it was nearly 7:00 a.m., and the time for the boat to leave the dock was approaching

rapidly. The captain was eager to shove off, believing that if he could get into open water, he could right any list the ship had. The harbor master and select members of the crew were not so sure.

The ship had righted itself when the ballast tanks were initiated. What happened next would become open to debate for years and still has not been solved. Something caused the passengers to start to swarm toward the river side of the boat. Some have said that a fast and fancy boat came roaring past, attracting attention, but others say that there were several rowboats in a race that plowed through the water nearby. No one knows for sure, but suddenly the *Eastland* began listing badly toward the river once again.

The captain called for his engineer to adjust the ballast in the tanks and right the ship a second time. The painfully slow process was carried out, and once again, the ship slowly righted itself. The captain remained eager to stop the flow of people and get his ship on the water. The captain requested a tugboat to help the *Eastland* pull away from the dock just before 7:00 a.m. The tugboat *Kenosha* arrived and took up its position at the front of the *Eastland*. Just as the tugboat arrived, however, the *Eastland* began listing toward the river yet again.

This time, the captain decided that it was time to leave. He was still sure he could right the ship once it got into open water. He ordered the gangways pulled up. The harbor master noticed the list and ran forward, waving

his arms and telling the captain that he had to correct the list before he could leave.

The captain ordered the number three port ballast tank to be pumped out. It is unclear why he didn't also order the number two ballast tank emptied, as that would have helped. By this time, the boat was listing so much that the people onshore noticed it. However, no one was overly concerned, and laughter could be heard coming from the boat. The grumbling crowd on the docks was ordered to the remaining ships. The *Eastland*'s passenger tally was about twenty-five hundred.

By 7:15 a.m., the list had become serious. The crew was worried. A radio operator on the *Eastland* named Charles Dibbell started talking to the crowd of passengers still mostly huddled against the railings on the river side of the boat. He asked them to start moving away from that side of the boat, and other crew members also stepped up to try and redistribute the weight.

Meanwhile, a man across the street from the *Eastland* looked out his office window and was shocked to see how badly the ship was listing. He called a co-worker and pointed to the boat. Witnesses estimated that the list to port was about ten to fifteen degrees by this time. The captain finally became worried enough to order the number two and three ballast tanks filled again. Seven minutes went by before water finally entered the tanks.

At about 7:20 a.m., the *Eastland*, for a third time, managed to right itself. The ship now stood straight,

but the captain and other members of his crew noted that the ship still felt unstable. Despite this, the captain ordered that it was time to cast off. The tugboat began to maneuver, and the passengers moved toward the wharf side of the boat to watch the crew casting off. The *Eastland* made it only a few feet from the dock and then listed to the port side. It quickly stabilized.

Just before 7:30 a.m., the ship listed to port again, and water began washing over the main deck through openings placed there for cleaning and drainage purposes. The passengers backed away from the edges of the deck, and the first yells of concern could be heard. The engineer ordered that the engines be stopped, and in the bar, beer bottles and glasses slid off of their resting places and crashed to the floor.

The passengers tried to move, en mass, toward the starboard side of the boat. Despite this, the *Eastland* continued tipping inexorably toward the water. Meanwhile, the captain ordered the tug to keep pulling and the engines to be turned back on. But the *Eastland* seemed to want to give up. Passengers near the back of the ship and near the engine room were told to move forward and toward the starboard side as quickly as possible.

Despite the captain's insistence that things were going to be OK, things on the *Eastland* were getting worse. Water rushed through port gangways, and the crew in the engine room reported water entering via the port

side. The river was rising up to meet the *Eastland*. A crew member opened a Modoc whistle to alert everyone around for miles that something was horribly wrong and likely fatal on the *Eastland*.

The captain still believed that moving into the river was going to correct the problem. He ordered the last remaining lines cast off and the engine room to stand by for further orders. However, the harbor master ordered the ship not to leave.

During interviews of the dozens upon dozens of witnesses to the disaster, all agreed that the ship had a twenty- to twenty-five-degree list at this time. The rear end of the ship, where the lines had already been cast off, began to move away from shore and into the river. The passengers, confused and frightened, believed that the ships was leaving port, and they once again moved toward the river.

The ship made one last attempt to right itself. Once again, it was nearly stabilized, but after a few seconds the listing recommenced. This time it was fast and deadly. Water correction that had been made was quickly lost, and there was no stopping the giant, top-heavy ship from going over. Water came rushing in, and the captain screamed in vain for the tanks to be filled and the pumps activated. The crew down below, tending the boiler, was unable to stand upright any longer.

Those below deck rushed toward the upper deck. Several crew members headed for the side near the dock

and tried to clamor for shore. Other crew members tried to get the passengers to move toward the other side of the ship in the hopes that their weight could right the ship long enough to get people off. However, the passengers were in their Sunday best, and their shoes couldn't find purchase on the slick decks.

The list reached forty-five degrees. Everything on the ship that wasn't nailed down began to move. Glasses, plates, tables, chairs and pianos crashed toward the river. The passengers panicked and rushed toward the wharf side, but it was too late. There was nothing that could save the *Eastland* now.

The captain began screaming for the gangways to be placed back on the ship. He still believed that he could get passengers off of the boat. Those gangways never even got close. The *Eastland* began its final list and rolled completely onto its port side. The water wasn't deep, and the boat was only twenty feet from shore, so the great ship quickly hit the muddy river bottom and lay on its side like a giant beached whale.

The boat lay in only twenty feet of water. The sound of screams filled the air as those on the top of the boat fell into the fast-moving, muddy river. All of the men, women and children were in their Sunday best—jackets, pants and vests or long dresses. These became sodden immediately, pulling the flailing, helpless people down rapidly.

The roll had happened fast, and until it happened, the crew and the captain were sure that they were going to

fix the problem. No lifeboats were manned. Everyone on the *Eastland* were on their own.

The screams in the river were horrible. Boats, including more tugs and other pleasure boats, as well as witnesses on the shore, filled the area. The true horror lay inside the *Eastland*. The furniture had trapped dozens upon dozens of helpless people inside. The muddy water was relentless, seemingly filling every available space with its cold, life-sucking presence.

Entire families screamed from inside the metal hull. Fathers held children above the water until their strength gave out and they sank beneath the surface. Entire families were wiped out as rescue efforts began on the surface.

Workers from nearby construction sites brought torches and began cutting holes in the side of the hull that lay above the water line. The men worked frantically, spurred on by the screaming and the increasingly feeble pounding. Before long, huge square holes appeared in the side of the hull, but more often than not the workers pulled sodden and drowned men, women and children from inside and carried them across the street to where a makeshift morgue had been set up.

Rescue divers, relatively new for that time, show up and were fitted with bulky suits and helmets. Their air hoses were checked, and the divers sank beneath the murky surface of the water. These men searched until they were physically unable to move, pulling bodies from the sunken hulk and from the water.

The newspapers, for the next few days, were filled with photos of the tragedy. One famous photo summed up the entire incident. It showed a fireman, eyes wide with shock and mouth turned down in sadness and despair, holding the limp, drowned body of a little girl in his arms. The day was soon labeled the "Day Chicago Cried."

When the boat was eventually lifted off the bottom of the river, the final search for bodies was completed. In the end, 844 men, women and children lost their lives a mere twenty feet from shore. In some cases, bodies were carried away downriver and never seen again. Twenty-two families were wiped out, and many, many more were psychologically scarred by the sights and sounds they witnessed.

An inquiry was started. The captain was accused and had to be rescued from a lynch mob on the day of the accident. He immediately blamed the passengers. Since many of the passengers were poor and from "Bohemian" countries, he accused them of being of "low character" and "ignorant" and therefore ultimately responsible for their own fates. This did not make him any more popular with the public.

Ultimately, the ship was declared top heavy. The ballast system for moving water from one tank to another was deemed inadequate. The added weight of the lifeboats in the wake of the *Titanic* disaster was pointed out, but no one in particular was held responsible for the disaster.

The *Eastland* remains the worst shipping disaster within the borders of the United States. Today, one of the buildings that was used as a temporary morgue is part of Harpo Studios, where Oprah Winfrey's show is produced. There is a small plaque near the spot on the river where the accident took place.

The *Eastland* itself was carted off and replaced. Its name was changed, and it went back into service. For a while, it was a gunboat. It served the military for some time, often as a training vessel, but was eventually decommissioned and turned into scrap.

The incident has largely been forgotten by the world outside of Chicago. Even during its day, it vanished from the headlines rapidly. Europe was about to break out into a world war, and that soon pushed the *Eastland* off the front page and out of many people's memories forever.

CHICAGO THE "BLIMPOPOLIS"

It seems strange to think about it now, but there was a time when airships were considered the transportation of the future. At the turn of the century, airships were being used throughout the world as a way to transport goods and people more quickly than could be done by boat, with the added benefit of being able to travel

incredible distances without having to refuel. It seemed like the perfect way to travel.

Chicago had been a hub of transportation for a long time. It was a center for shipping throughout the Midwest, and its position on Lake Michigan was perfect for that purpose. When rail became the dominant form of transportation, Chicago became the biggest train hub in the country. It was said that all tracks led through Chicago.

When people began to consider blimps and airships as replacements for the railways, they naturally thought that Chicago would become a hub for airship travel. There were plans in the works to have several airship stations in the city. One future-looking person said that he envisioned Chicago becoming a "blimpopolis."

This was put to rest, however, on a sunny day in the month of July. It was 1919, many years before the *Hindenburg* would finally put an end to airship travel once and for all. It was a hot day, and the *Wingfoot Air Express* was to make its one and only appearance to the world.

The *Wingfoot Air Express* was scheduled to take off on the south side of the city, an area known as White City. White City was actually an amusement park that had once been the midway for the famous Colombian Exposition some years before. It had a large open field that was used for testing airships and blimps.

The *Wingfoot Air Express* was the latest airship designed and built for the Goodyear company. Of course, the

Goodyear blimps would become famous in later years, but at that time they were the only airships around. The *Air Express* had some new features that needed testing. The first were called ballonets, compartments for confining the hydrogen gas used to lift the ship into the air so that if one compartment was punctured, the other compartments would remain intact. The second feature was a new array of propellers, located in front of the two rotary engines rather than behind them as they had been in the past.

At about 9:00 a.m., the pilot of the *Air Express*, John A. Boettner, pulled on his parachute and climbed into the gondola. He settled behind the controls of the ship. The gondola hung below the bags of gas that would lift the airship into the sky and was designed to hold about ten passengers, in addition to the small crew. Joining Boettner that morning was a mechanic employed by Goodyear named Carl "Buck" Weaver and the ship's only passenger, Joseph C. Morrow, a colonel in the army air service. Morrow was making his first official airship flight.

The *Wingfoot Air Express* was pulled out of its hangar by the ground crew after the men were all in their seats. The engines were primed and then started; the new propellers turned without a hitch and began humming. Boettner did some preliminary checking of the engines and then signaled for the ground crew to release the airship. The restraining cables and ropes were released, and the stern swung into the air followed by the bow.

The *Air Express* floated upward gracefully, gaining altitude rapidly in the hot and humid July air. The airship headed east, toward Lake Michigan, and then turned northward when the lake was to the east side. Downtown Chicago lay ahead, and Boettner intended to give the workers and people strolling downtown a show with his impressive new airship.

All seemed to be going well. Workers outside were treated to the sight of the huge airship gliding gracefully through the sky. Employees and shoppers stood outside and pointed upward, marveling at the sight. The first leg of the journey planned for that day was almost at an end. Grant Park was right in the middle of downtown Chicago, and it was to be a docking area for airships. The *Wingfoot Express* headed for that spot now, and the ground crew came out to meet it. Cables and ropes were used to wrestle the ship to the ground.

Boettner and some of the crew inspected the new airship while all around gawkers paused to watch. Colonel Morrow departed at that time, but two more passengers were picked up. Earl Davenport, a one-time newspaper reporter who now worked as a publicity man for Goodyear, climbed into the gondola. He was accompanied by William G. Norton, photographer for the *Chicago Herald and Examiner* newspaper.

The inspection detected nothing wrong with the airship, and the signal was given for the ship to take off

again. Once again, the handlers on the ground released the mooring ropes and cables, and the airship sailed majestically into the air. Below, the onlookers applauded.

Norton was the one who told Boettner to deviate from his planned course. He wanted to get some aerial shots of downtown Chicago, and he urged Boettner to fly over the city and the skyscrapers. Down below, workers in the Loop, many of whom were outside trying to cool off from the oppressive heat, looked up and marveled at the ship as it slowly passed overhead.

It was now late in the afternoon, and many workers were getting ready to head home. Hundreds of people were soon pouring out of the buildings downtown, only to look up in wonder at the vision slowly moving over the rooftops. It was a marvel to behold.

Then the horrified onlookers started to scream as flames suddenly erupted from the stern of the aircraft. The outer skin of the airship burned bright and fast, and the blimp collapsed. Parachutes and falling men suddenly flew from the gondola. As the terrified witnesses watched helplessly, the gondola and skin of the aircraft turned into a flaming fireball and plummeted from the sky, passing the parachutes as it fell and turning them into flames as well. The disaster was only beginning, however.

Beneath the flaming wreckage was the Illinois Trust and Savings Bank. The bank was known for its elegant marble lobby. The lobby was dominated by

a huge cage-like area where the tellers worked. High above the huge, open marble expanse was a large glass skylight. This skylight let in light throughout the day, bringing a little bit of the outside into the space for customers and workers alike.

As the *Wingfoot Air Express* died its flaming death in the skies above, the clocks approached 5:00 p.m. The bank tellers were finishing up their final tallies and preparing for the following day. It was customary for the tellers to wait for everyone to finish and then gather by the door to the cage to exit at one time.

The president of the bank, a man named John J. Mitchell, had left early. He had to catch a Chicago and North Western train to the city of Cary, where he made his home. He had waved goodbye to his employees and exited the building, rushing for the train station.

As the workers began to gather, they joked and discussed plans for the evening. Meanwhile, above them the *Wingfoot Air Express* was plummeting like a flaming stone. An ominous shadow suddenly fell across the skylight. Some employees had enough time to look up.

The iron grill and glass skylight exploded inward. Hundreds of pounds of jagged glass and twisted metal fell on the 150 employees still huddled in the area behind the barred windows and high counters. The flaming engines were the heaviest part of the ship, and they came through first, followed by glass and iron from the skylight.

The engines, still partially filled with fuel, literally exploded when they hit the floor. The white-hot pieces of engine became deadly shrapnel, spraying the rotunda. The gasoline in the tanks erupted, hitting the flames and igniting immediately. In a span of seconds, the entire area became a mass of shrapnel and then a mass of flames.

The shattered skylight became a kind of chimney and began sucking the flames upward, fanning them at the same time, turning the area beneath into a kind of tornado of fire. The wooden furniture, desks and counters soon caught fire.

One employee screamed that it was raining hell as the flames leaped up the marble columns, now sprayed and soaked with gasoline. The exits were blocked by flames.

The men who were in the airship were not faring any better than those below. Davenport had been unable to get out of the gondola. When it fell, he fell along with it until the gondola hit the bank building. He was thrown with such force that when he was found later, he was half in and half out of the roof of the bank.

Norton, the man who had convinced the pilot to deviate from his course so he could take photos of the skyscrapers, held onto his plates as he jumped. However, attempting to hold on to his heavy plates and camera meant that he was unable to control his parachute, which soon became entangled on the Western Union Building. He was smashed against the side of the building and then

fell all the way to the street. He survived for a few days, but ultimately slipped into a coma and died, all the while asking if his photos were safe, even though his camera and plates had been smashed to pieces in the fall.

Boettner, the pilot, was luckier. He was able to bail out and guide his parachute out of the way of the flaming wreckage. He floated to the ground and was nearly unscathed. The mechanic, Weaver, was unable to get out of the way of the wreckage, and his parachute caught fire. He fell straight down, right through the broken skylight and to floor of the bank, where he died and then burned.

All-out pandemonium had erupted inside the bank as employees tried to get out of the building. Some managed to walk back toward the office areas, away from the rotunda, and some jumped from second-floor windows and higher. The air filled with hopeless screams as people burned alive.

The fire department was there in minutes, after hundreds of witnesses saw the accident. Firemen forced their way inside and began spraying water. Just seconds before their arrival, the gondola had plunged through the broken skylight, carrying the burning skin of the ship with it to the floor. Weaver's body ended up beneath the wreckage.

It took about thirty minutes for the firemen to put out the fire. What they saw after that was destruction beyond anything they had seen before. Bodies were piled up on

top of one another, some burned so horribly that they were unidentifiable. Blood lay in pools on the marble floor, filled with glass, gasoline and parts from the airship. Thirteen people were dead and twenty-six were injured.

The bank president was informed of the disaster, and his train was stopped on the way home. Another train, this one heading back downtown, was held for him. He switched trains and immediately headed back downtown to see what he could do. His employees were insured, and he vowed to the press that the needs of the families would be met.

Goodyear stepped up and set up a fund and commission to settle the death claims. It was hoped that this would head off any legal actions by the survivors and the injured. It mostly succeeded, even though a court declared that those affected by the accident could sue the company for reparations if they wished.

In the inquiries following the accident, the pilot and those who had ridden the *Wingfoot Air Express* that day testified. The pilot claimed that he had no idea what caused the fire. He said that he saw flames out of the corner of his eye and knew, almost immediately, that the ship was lost. He bailed and guided himself to the ground.

Some debate was made over whether the airship was faulty. The military man who had been on the airship for the first leg of its journey testified that he felt the ship was in perfect working order. He claimed that

had he felt otherwise at any point he would not have boarded the ship.

Legislation was proposed to ban air traffic over the densely populated Chicago area. However, the legislation soon fell out of popularity as the story of the *Wingfoot Air Express* vanished from the headlines. Even in the bank, employees returned that very night to clean up. Equipment was borrowed from other banks, and after five minutes of silence for those lost, the bank returned to business the very next day.

Of course, Chicago never did become "blimp central" as some had predicted. It did become a major air center, but for the increasingly popular airplanes and not airships. Airships themselves continued for a while but were decommissioned in the 1930s following the *Hindenburg* disaster. The *Wingfoot Air Express* disaster, meanwhile, faded into obscurity.

THE AMAZING FORGOTTEN CEMETERY AND THE MYSTERY OF BACHELOR'S GROVE

Throughout the history of this country and the history of the world, cities and towns were founded, grew up and then disappeared. Sometimes they were mysterious, such as Cahokia Mounds or early settlements in the United States. Other times the towns just moved

on or geography or the economy changed and did them in.

Exactly what happened to the town of Bachelor's Grove is not really known. This small town was located just south of Chicago. The area is now near the suburb known as Midlothian. These days, however, the area has become famous for reasons that have to do with the tiny cemetery that was left behind and the rumored goings-on there.

The original area was chosen as the cemetery for farmers, such as Clarence Fulton, who was once the caretaker of the cemetery. Today, the cemetery is not in use, although former residents of the area were being buried there until 1965.

At one time, the area surrounding the cemetery was a small town that early maps indicate was called Bachelor's Grove or, perhaps, Batchelor's Grove. There were homes and other structures making up a town. The cemetery was a key part of life within that town.

The cemetery is now the most famous part of the town. It is located within a forest preserve that is manned by local government and patrolled by the state police. To get to the cemetery, one has to walk down a long and lonely road that is barely noticeable from the busy road that roars past it. There is no indication that the cemetery is there. To walk or drive down that road is actually considered trespassing, and it is patrolled heavily.

When the town was there, residents would actually spend days picnicking on the green grass that made

up the cemetery. There is a large lake where residents would swim.

Something happened. Economic times changed. People began growing up and moving away. The small town became smaller and smaller. There was no great cataclysm; there was no fire. People simply decided to leave, and their homes were sold. Bachelor's Grove became parts of other towns and cities. All that was left was the cemetery.

In fact, even the cemetery was largely forgotten for some time. It was off the road known as the Midlothian Turnpike until the 1960s, when that particular branch of the turnpike was abandoned in favor of 143rd Street, which shifted the traffic patterns. Once this happened, it was only a matter of time before local teenagers found the short abandoned road and turned it into a "lover's lane."

Those teenagers eventually came across the gates that barred the entry to the cemetery. A huge sign across the archway read "Bachelor's Grove." Beyond that were the gravestones of the people who used to live there. Unfortunately, the teenagers found vandalizing the cemetery to be part of the fun.

At one time, it was estimated that there were over two hundred tombstones in the cemetery. After the teenagers found the place and decided to tear it apart, there were maybe twenty tombstones left. These were mostly tombstones that were too heavy to be moved.

Most of the tombstones were dragged from their original locations and thrown into the lake. There has been evidence of graves being tampered with as well. Even the remaining tombstones have been chipped and vandalized. Today, the weeds have overgrown the remaining tombstones, and they are faded and hard to read.

Within the cemetery, the largest tombstone is the one belonging to the Fulton family. One of the gravestones there is that of a child, and the ground around that tombstone is littered with trinkets, small toys and stuffed animals left by visitors. It is within the gates of this cemetery where the tales of hauntings begin; Bachelor's Grove has earned the nickname of "Most Haunted Place" in northern Illinois.

The strange thing about Bachelor's Grove is that it has haunting phenomena that are not described in many other places. For example, it is one of the few places on earth with a tale of a ghost house. There are remnants of what seems to be a foundation along the road to the cemetery, where some believe a large house once stood. Sometimes, it is reported, those who travel along this road will see a house, complete with a front porch and porch swing. It is so real that some have stepped through the wooden gate and up to the front porch, but when they head back toward their car after visiting the cemetery, the house is always gone. Sometimes the sound of the porch swing is all that people hear.

There are rumors that satanic rituals have taken place in the cemetery. There has been evidence of sacrifices and vandalism that seem to show satanic symbols. This has only helped to fuel the rumors of ghosts in the cemetery.

The tales of ghosts are what made Bachelor's Grove Cemetery famous. It is considered the most haunted graveyard in the world. Of course, this brings about curiosity-seekers who seem more interested in bringing back a souvenir than preserving the history of the place. There has been a movement by some independent organizations to preserve and restore the cemetery.

The cemetery became very famous when, in 1991, ghost hunters came to see what they could find. The

findings have become almost as famous as the cemetery itself. In one photograph taken with infrared film, a woman in white is sitting on top of a grave. No one was there when the photograph was taken.

The pond is also reportedly haunted. There have been suggestions that Al Capone and other gangsters used the deep and dark water as a place to dispose of bodies. There is another legend about a farmer who was plowing his fields when his horse bolted. As he tried to hold on, he was dragged into the pond. Both he and the horse reportedly drowned. Some claim to see ghostly images of that farmer and his horse in and around the dark waters.

Today, the cemetery is part of the Cook County Forest Preserve. The section is once again named Bachelor's Grove on local maps. The last remaining portion of a road that was once known as Bachelor's Grove Road was closed in 1994.

Ghost hunters still come from around the world to walk down the lonely road that leads to the isolated and forest-enshrouded cemetery. During the Halloween season, this is particularly common. Of course, these days the forest preserve police attempt to keep what little is left of the cemetery intact. Cars parked on the road near the cemetery will be ticketed and towed. Those found wandering the grounds of the cemetery or the roads might find themselves fined or arrested.

Still, the idea of coming to one of the most haunted places in the country is just too tempting for fans of ghost stories. Perhaps they will see the phantom house or the mysterious farmer and his plow. Maybe, just maybe, the white lady will make an appearance in their photos.

BOB ANDERSON AND THE FLOOD

Large areas of Illinois are along major rivers in the United States. The entire western border of the state is carved by the Mississippi River. In southern Illinois and parts east is the Ohio River. Bob Anderson grew up near the Ohio River, just beneath Cairo, Illinois, in a town called Wickliffe, Kentucky.

Bob Anderson grew up watching the river would rise on occasion and destroy homes, fields and businesses. He knew, from the time he was young, what to watch for and how to react. He knew the dangers.

He also loved radio. Of course, the actual invention of radio didn't come around until he was older, but when it arrived, people across the country jumped on the radio bandwagon and started broadcasting from their homes. Bob was among them. His degree, from the University of Kentucky, may have been in industrial chemistry, but his heart was in radio.

Bob moved around the state of Kentucky after college before a friend offered him a job in Harrisburg, Illinois. He was to be a service manager for a radio and refrigerator firm located there. Bob liked the small town, bought a home, played the piano and organ, got involved in the local radio station, where he built and rebuilt equipment, and started a family.

Things seemed fine until January 1937. Harrisburg was in Saline County, which was quite far from the Ohio River. It was considered safe from the risk of flooding. However, that January the river began to reach record highs. The water soon reached the gates of Harrisburg.

Huge parts of Illinois were flooded. Inland seas were formed almost overnight as the river found low spots and expanded. Smaller towns in flood plains were hastily evacuated. Soon, those in Harrisburg began to worry about a small community not far from town called Shawneetown. The town had only about fifteen hundred people, but it was very close to the Ohio. It had levees, but the water was rising so fast that it was obvious that they were not going to hold forever.

Back then, there were no weather watches and warnings. In fact, most of the people in Shawneetown, confident in their levee system, were not truly aware how dangerous the situation had become. One person who knew was Bob Anderson.

Bob had gone over to the local radio station to discuss what would happen when ice began forming on the power lines and phone lines. The radio station had been monitoring the river, and there were plans to send a reporter to Shawneetown to report on what was happening there. However, it looked like the weather was getting worse, and the manager at the station asked if Bob would be willing to set up a kind of remote station and broadcast from the community.

Bob could tell that things with the river were getting serious. He knew it would be dangerous, but he accepted the challenge and went home to tell his wife. Reportedly, she was not too happy about his decision, but Bob was determined. His wife prepared a hot meal for him, and

Bob gathered up the materials he would need to create an improvised transmitter—a battery receiver, spare batteries and other necessary equipment. He put them into a truck and, after a quick stop at the radio station, headed for Shawneetown.

Bob took a roundabout way to try to cross the river. He found the road underwater at several points. Eventually, however, Bob had to admit defeat. He tried to find someone with a boat to get him across the river and into Shawneetown. At first, he had difficulty convincing anyone, but when he told them he had radio transmitting equipment, he found volunteers.

Two river men loaded their boats with his equipment and began rowing through the ice cold air, freezing rain, snow and rapidly moving water. There was only one telephone wire still intact by the time Bob made it into Shawneetown. When he got there, he learned that the town was short on bread and other necessary items. Bob decided to set up his transmitter to get the word out.

It was originally proposed that he transmit from the local coal mine offices. However, the managers of the coal mine asked him to keep moving farther into town. Bob got back into the boat and found the next part of the river even more treacherous. As he was traveling, Bob ran into a bread salesman with a truck full of bread. He informed the man of the need in Shawneetown, and the bread man loaded the already heavy boat with loaves of bread. He joined Bob in his trip.

Eventually, Bob and his traveling companion were given use of a boat with a motor. They managed to cross the next part of the river and reached the railroad crossing near a place called Junction. This was the last community before Shawneetown. They found an abandoned house and tried to stay warm. Bob began setting up his transmitter.

He had the transmitter set up fairly quickly, despite the weather. The one problem he found was that his transmitting antenna was just a thin piece of wire. He tried to transmit, but the wire was being mercilessly blown in the winter storm and ice was building on it quickly. Eventually, he and some other men from town rigged up a better antenna.

Bob began trying to transmit to the radio station in town. However, the radio waves were being battered by the harsh winter storm. The receiver at the radio station got little more than static, but radio station W9ELL in Louisville was able to hear Bob's transmissions and also transmit and receive from the radio station in Harrisburg. The radio operator at W9ELL agreed to be a relay.

Bob transmitted that food was needed and that all medical supplies were short. He also transmitted the road conditions and the fact that the river was dangerous. The wind and storm were so bad that Bob soon shifted from trying to transmit using his voice to using Morse code.

The station in Harrisburg was asking for details. It wanted Bob to send someone into town to find out exactly

what was needed. Bob, on the other hand, took one look at the weather and the river and told the operator that he needed to send someone if he wanted to know so bad. Also, he expressed the desire for someone to come rescue him; after all, he was in as much danger as Shawneetown. That was how Harrisburg first learned that more than Shawneetown was in trouble.

Bob sent a message to his wife that he was OK. He also mentioned the bread man who had come forward with food for the stricken town. He continued to pound away at his key, sending what information he was able to gather as the batteries that powered his tiny station reached their maximum time limit.

Back at the station in Harrisburg, the messages were scribbled in the margins of a newspaper. They were then read by flashlight. Bob Anderson's fingers grew numb with cold and overuse.

At some point, the W9ELL operator had to break in and say that he could no longer be a relay. Situations in Louisville had prompted him to turn his attention elsewhere. Just then, a radio station in Wheeling, West Virginia, W8CXR, came on the air. It had been tuning in and volunteered to continue the relay. This meant that the signal was now traveling from Junction, Illinois, to Virginia and then to Harrisburg. Junction and Harrisburg were only seventeen miles apart, but the messages had to travel almost one thousand miles.

By 3:00 a.m., Bob's batteries were dead. W8CXR informed Harrisburg that Bob had gone off the air. At that, the radio station in Harrisburg sent out a plea for anyone with a boat and supplies to head to Junction and Shawneetown.

A man named Jack Hatfield, a friend of Bob Anderson, heard the plea and immediately set out. He arrived just before daybreak and found thirteen shivering men. He helped them load the people and the radio equipment into his boat. During the transfer, Bob lost some equipment to the river.

With the boat crowded with people and radio equipment, the men headed for Shawneetown. The roads were flooded, and street signs loomed eerily out of the water. The small boat tore through ice that had formed on the surface of the river.

Bob Anderson was soon able to set up his radio station again. He had some fresh batteries, and he began to transmit. Messages directly from Shawneetown were now being transmitted.

Officials in Shawneetown gave Bob Anderson the full facilities he needed. They gave him a table in a local bank building, where he could keep working. They even provided him with a blond stenographer to take the incoming messages, as well as shorthand, for him.

In addition to providing help with the transmissions, the stenographer also provided him with food and further supplies for his radio station. She even managed

to find him pants when he fell on some ice and tore his trousers at the knee.

Despite the calls and the people trying to get to the town, all hope of saving it was soon lost. The river, choked with ice and blocked, was rising faster than anyone could have imagined. Shawneetown was going to have to be evacuated. The question was, where could all of the people go? Five hundred desperate people crammed into the Shawneetown High School, which was on higher ground. They were literally packed in like sardines, each person having only about nine square feet of space.

Food was still a problem. There was also a need for medical supplies. People needed blankets and clothing. More importantly, Bob began transmitting pleas for help from boats capable of navigating the ice and the river. Those five hundred sad people were eventually rescued and taken to places in Indiana and Kentucky. Not a single life was lost in Shawneetown.

Bob finally prepared to return home. He was exhausted. He climbed into another boat and was taken back to Harrisburg, where he hoped to head back home and get some rest. Instead, he found that another amateur radio man was overwhelmed with requests from all over southern Illinois. Bob sat down and helped out his friend, taking and sending messages.

When things finally calmed down, Bob Anderson had been working almost nonstop for days. He climbed on top of a seventy-five-foot tower to adjust an antenna and

then climbed back down. He drove home, picked up his family, drove them to the hospital for typhoid inoculations and then, while at the hospital, promptly collapsed.

Bob Anderson was in bed at the hospital for two days and then spent another week in bed at home. The strain had been terrific on the slight man. It took him nearly eighteen months to fully recover.

Bob Anderson was too sick to accept the awards he was given for his selfless service of his fellow man. He was normally a shy and introverted man, but on that terrible day, during those terrible times, he rose above it. He was a quiet hero, but he saved entire families in the small towns in southern Illinois.

MATTOON'S "MAD GASSER"

The history of not only Illinois but also the entire country is littered with strange criminals committing some very strange crimes. Still, there is very little that is stranger than the events that happened in the small Illinois town of Mattoon during 1944. Today, they are known as the "Mad Gasser Attacks."

What makes these incidents so bizarre is that a series of very similar attacks took place in Botetour County, Virginia, in 1933 and 1934. Some who have studied these events have wondered if the Mattoon attacks were some

kind of mass hysteria. Others suggest that the reports were too widespread and too clear to be hysteria; besides, back then it was unlikely that little Mattoon would have heard about the goings-on in a small county in Virginia.

In both cases, there were reports of a strange figure, dressed in black, seen lurking outside of homes. Whoever this was left little in the way of clues. What is known is that this person was suspected of spraying some kind of paralyzing and sickening gas under the doors and through open windows into homes.

Mattoon is a small community today, and it was even smaller in 1944. It is located in central Illinois, and there were no large metropolitan areas anywhere near it. But the tale of the Mad Gasser really begins in Virginia. Like Mattoon, Botetourt County was quiet even by 1930s Virginia standards. Nothing much was reported there in those days. Most people, even those living in Virginia, had no idea the county existed. That started to change on December 22 at the home of Mrs. Cal Huffman.

At about 10:00 p.m., Mrs. Huffman was suddenly overcome with a powerful feeling of nausea. She stated that she smelled something strange and then just felt completely sick to her stomach. She told her husband that she was going to bed. He stayed awake, trying to figure out what the smell was and where it was coming from. At 10:30 p.m., Mr. Huffman smelled a second wave of the strange chemical. He grabbed his phone and called the local police.

One officer was sent to the home. He remained at the house until midnight and then left. Almost as soon as he left, both floors of the house were filled with the strange-smelling gas. By now, all eight members of the Huffman clan were affected. Cal Huffman, still awake and watchful, thought he saw a man running away from the house.

The gas reportedly caused those who inhaled it to feel very sick. It gave them headaches. The gas also, reportedly, caused the mouth and throat muscles to constrict. The person in the Huffman household who was most affected was Cal's nineteen-year-old daughter. She was given artificial respiration to bring her back to consciousness.

The problem was that no one could be sure what kind of gas was being used. One clue was found, and that turned out to be a woman's shoe print beneath the window where the gas was believed to have been sprayed. The mystery deepened.

The next attack was at the home of Clarence Hall. The Hall family came home from church on Christmas Eve. Not long after getting into the house and settling down for the evening, the strange odor was detected. Clarence walked to the back of his house in an attempt to track down the smell and soon came staggering back, his vision blurry and his stomach lurching. Soon, his wife also started to feel sick. His children and wife helped drag him outside, and they left the doors open.

The gas did not linger, but the Hall family was treated by their doctor for several days afterward for eye irritation and sickness.

More attacks occurred. Another happened on December 27. This time, however, police heard a report of a man and a woman in a 1933 Chevrolet driving up and down in front of the house where the attack occurred. A partial plate number was even captured. The police never tracked down the car.

The gasser took a break until after the first of the year, and then the attacks started again. The first was on January 10 at the home of Homer Hylton. A second attack, this time at the home of G.D. Kinzie, also occurred. At the second attack, a doctor visiting the home said he thought he smelled the gas chlorine. The gasser took a few nights off and struck again on January 16. More attacks happened on January 19, 21, 22 and 23. Then, on the twenty-fifth, another attempt was thwarted when a dog started barking, alerting the home owner, who ran with his shotgun into his yard. He took a shot at an unidentified man he said was creeping in a ditch about twenty feet from his house.

After that attempt, the police investigated and found footprints. There was more evidence of someone having hidden behind a tree, probably for a long time, watching the house.

One more attack happened on January 28. The same residence was attacked twice on that day. Then,

the final authentic attack happened on February 3. After that, the attacks stopped as mysteriously as they had begun.

In Virginia, there were reports of other attacks, but these were chalked up to mass hysteria and panic. No further evidence was ever found to determine who might have done this or what kind of gas had been used. Eleven years later, attacks of eerie similarity happened in Illinois, creating an even bigger mystery.

Mattoon was very much like the Botetour County in Virginia. It was a very stereotypical small midwestern town. There was absolutely nothing out of the ordinary about Mattoon. That changed in the early morning hours of August 31, 1944.

The sun was just barely peeking over the horizon when a Mattoon man awoke suddenly and shook his wife awake. He told her he felt sick. He asked her if she had left the gas on in the kitchen. His wife made an attempt to get out of bed to check the gas, but as she stood, she was surprised to find that she couldn't move. Minutes later, to add to the strangeness, a woman who lived in a nearby home also awoke from her sleep to find herself paralyzed.

It wasn't long before the strange incidents happened again. In fact, the very next night, a woman named Mrs. Kearney awoke in the middle of the night to an odd smell. She later described the smell as sweet and overpowering. The smell grew stronger and stronger,

and as it did, she felt her legs going numb and then become paralyzed. She began to scream, which woke her neighbors. The police were called. The next day, she complained of burned lips and a parched throat. The police and her neighbors quickly checked her yard, searching for clues, and found nothing.

Later that same night, Mr. Kearney returned home from work, and as he approached his home, he saw a man creeping around his house. Kearney told police that the man was wearing dark clothes and a dark cap that fit tightly to his head. The man was standing near the window, and when Kearney approached, he stood up and ran away. Kearney immediately gave chase, but the man was able to outdistance him.

After this event, the Mad Gasser became public knowledge in Mattoon. Stories began appearing in the local paper, and the town was soon in a panic. The authorities did a very poor job of getting a handle on the situation or putting rumors to rest. Meanwhile, the local papers were jumping on this strange story and amping up the fear. Mattoon soon found itself in the midst of "Gasser Hysteria."

By the time September 5 came around, the Mattoon police department had been bombarded with phone calls from panicked residents reporting gas attacks. At least four of them complained of a sweet odor and paralyzing effects. However, there were no further clues—until that night.

Carl and Beulah Cordes came home and found a cloth lying on their front porch, near the front door. When Mrs. Cordes picked up the cloth, she held it near her nose and was immediately overwhelmed with a feeling of nausea. As if she was having some kind of severe allergic reaction, her lips began to swell, followed by her face. Her mouth actually started to bleed. The police were called, and they took the mysterious cloth as evidence. They searched the porch and found a skeleton key and an empty lipstick tube.

The police studied the strange cloth. They determined that the cloth had something to do with the previous gas attacks, despite the fact that Mrs. Cordes had experienced different symptoms than those who had reported the earlier attacks. She had not been paralyzed, just nauseated, which was more like the attacks in Virginia eleven years earlier.

The Mad Gasser attacked again that very night. This time, he was back to spraying gas through an open window. A woman in the home claimed that she saw a person wearing dark clothing trying to force open the front door.

The reports of attacks continued. More descriptions of the Mad Gasser surfaced. He was described as tall and thin, wearing dark clothes with a tight black cap on his head. The police had to check out each report and tried desperately to keep up. However, they were soon overwhelmed, and they called in the FBI from Springfield to lend a hand.

Things soon turned from crazy to dangerous as citizens tried to take the law into their own hands. Bands began roaming the streets with weapons. Some residents began forming patrols and watches. Despite this, more attacks were reported, and at least some of them were confirmed. Now, however, the Mad Gasser was leaving behind more evidence in the form of footprints and sliced window screens.

Word was spreading beyond Mattoon. Politicians in and around the town were embarrassed that they couldn't catch this man. One suspect was grabbed by one of the mobs and brought in, but he passed a polygraph and was let go.

The next attack was at the home of Violet Driskell and her daughter. Both women awoke in the middle of the night when they heard someone removing the storm sash of their bedroom window. They hurried out of their beds and tried to run outside, but as soon as they stood up, the fumes overcame the daughter and she vomited. Violet later told police that she saw a man running away from the house.

The Mad Gasser was never satisfied with just one attack a night, however, and later that night Mrs. Russell Bailey, Katherine Tuzzo, Mrs. Genevieve Haskell and her son were all sleeping when gas was sprayed through an open window of their bedroom. In another home, also that night, Frances Smith, a principal at the local high school, was overwhelmed, along with her daughter, by

a strange smell. They also complained of paralysis and described a sweet odor. They described hearing a strange sound from outside the window, which they guessed was the spraying device.

By now, the FBI agents were frustrated. The local police were struggling to control the vigilante groups roaming the streets.

Some began to worry that the Mad Gasser was a myth. Newspapers began to report that there was evidence that all of the attacks were some kind of mass hysteria. Some claimed that it was women looking for attention. Since it was war time and many of the women's husbands were overseas fighting, this theory was given credence.

The gas attacks began to diminish. The police chief made a statement on September 12 that the large amounts of tetrachloride gas being used at the local Atlas Diesel Engine Company was likely the cause of the nausea. It was theorized that wind currents could have carried this gas throughout the town and even left the strange stains found on a rag near one of the attacks.

There was one more reported attack on September 13, and then, like a switch had been thrown, the attacks stopped. The Mad Gasser was never heard from or seen again in any part of the country.

So, who was the Mad Gasser? To this day, no one knows for sure. Given the number of years since the attacks and the fact that no further attacks were

reported and no more evidence was found, it is unlikely that the case will ever be solved. Was it real, or was it just mass hysteria?

THE CRASH OF THE GREEN HORNET

If you have any images of Chicago, one of the things you probably think about is the El, or elevated train, which crisscrosses downtown. It carries hundreds, thousands, even millions of people across the city. The city also has subways, as the cars do go below ground in addition to riding high above the streets. There are also buses and commuter trains. Of course, the roads are clogged with cars, and many of the streets are narrow. It is hard to imagine a time when these streets had streetcars traveling down the middle, but such a time did exist.

Once upon a time, the roads of Chicago, extending almost all the way out to the suburbs, were crisscrossed with tracks, above which were endless miles of electrical wires. Across those tracks and attached to the wires were cars that ran on the electricity provided by the wires. These cars carried countless passengers. Each car was about the size of a modern city bus.

Before electricity, the streetcars were pulled by horses. They were a main source of transportation in the city

for a very long time. However, by the 1950s, there was a movement afoot among city planners to get rid of the streetcars. It was becoming difficult for cars to travel down the streets with the tracks. There was also a movement to start a standard bus system and focus on upgrading and maintaining the El system.

On May 25, 1950, an event happened that has become largely forgotten by the people who live here, but it changed the course of mass transit in Chicago. One of the newest streetcars, known as the "Green Hornet," was involved in a disaster that killed many passengers and turned the city toward buses.

In the late 1940s, the company that managed the streetcars in Chicago, the Chicago Surface Lines, had placed orders with the St. Louis Car Company, as well as Pullman, for six hundred new streetcars known as Presidents Conference Committee (PCC) streetcars. They were meant to replace the thirty- to forty-year-old cars that were currently being used and crossing the city. The new cars were actually designed to look almost exactly like the previous cars, except that with flatter fronts, a belt rail that was much more narrow and side windows that were slightly different.

The PCC cars were delivered a few at a time over the years after the order was placed and then put under the control of the Chicago Transit Authority. They were circulated throughout the city, and their greenish color gave them the nickname of "Green Hornets." The new

cars were shinier, a little sleeker, rode more quietly and were designed to accelerate rapidly.

The Green Hornets were meant to be run by two men. One of them was the driver and the other was the conductor, who sat near the rear entrance and sold tickets. The doors near the rear of the car were where the passengers entered, and they opened sideways. They were known as "blinker doors." There were more doors in the middle of the car and another set of doors near the front of the car. With this arrangement, the cars, during normal operation, were very quick and efficient at loading and unloading passengers. The windows were raised and lowered with crank handles, like those in an automobile. The windows could be cranked down low enough for someone very skinny to crawl out, but there were steel bars across the windows meant to prevent passengers from sticking their heads or hands out.

It was evening on May 25, 1950, and a Green Hornet numbered 7078 was on the Broadway–State route running from the north side of town all the way to the south side. Earlier in the day, rain had come through Chicago. The storms were brutal, dumping large amounts of rain in a very short time. This had flooded the viaducts that allowed cars to go under highways and train overpasses. So much rain had fallen that some streets had to be closed.

With buses, street closures don't pose a problem. Buses simply back up and turn around, or turn down another

street and take a route around the problem. When the vehicle traveling down the road is on tracks with overhead wires, the situation is much more complicated. The cars are required to switch to other tracks, taking them well off course around the obstruction.

One of the flooded viaducts was right in the path of Green Hornet 7078. Streetcars have electric motors and sit only a few inches above the ground. Going through water shorts out the cars, making them immobile.

A streetcar on the same route had been directed to turn back to a short loop just beyond the flooded area. At that short loop, there was a switch track placed at a slow curve from the southbound track and across the northbound track, allowing access to the loop track. When the streetcar in front of 7078 was done with its turn around, the switch was accidentally left open.

Meanwhile, car 7078 was going about its business as usual. It was a busy night, and the conductor was selling tickets and making sure people were getting on safely. The car was very full as it approached the area where the flooding had occurred and where the switch was left open.

No one is sure how exactly the accident occurred. Despite having a man with a flag well in advance of the flooded area, the driver of 7078 seemed not to notice him. Witnesses reported that the driver was driving at a very high rate of speed. He seemed not to be aware of the closed street ahead of him.

Meanwhile, driving in the opposite direction was a man in a truck. He had just gotten past the flooded area. The truck happened to be filled with gasoline.

Car 7078 barreled along its route, seemingly oblivious to what was ahead of it. The passengers were oblivious as well, sitting in their seats and looking forward to reaching their destinations. The car hit the open switch, and the driver seemed not to notice as the car suddenly veered into the northbound lane of traffic.

Witnesses say that the driver continued to be unaware of what was happening almost until the point of collision with the gasoline truck. At this point, he threw up his hands and screamed. The passengers began to scream as well. The streetcar hit the gasoline truck head on; neither vehicle slowed before impact.

The drivers of both vehicles were killed almost instantly. Gasoline sprayed across the car. Before long, metal struck against metal, and sparks ignited the gasoline. The explosion that followed blew windows out of shops up and down the street and damaged buildings for blocks. The ball of flame quickly flashed across the streetcar and turned the inside of the car into a hell of flames and burning gasoline.

The blast knocked down passersby. Once they realized what was happening, they ran toward the flaming wreckage. The "blinking eye" doors would not open properly to allow passengers out. Those who were able to crank down the windows found bars blocking their path.

Near the middle doors, a small girl looked up and saw an emergency handle. She reached up and pulled the handle, forcing the doors open. She and several others spilled out onto the street. Inside, however, other passengers had piled up against the remaining doors. The largest pile of bodies was against the rear doors, away from the flames. The conductor, situated at the rear door, had been thrown from the wreckage and escaped nearly unharmed.

The fire department arrived and began spraying water on the wreckage. It took some time for them to quench the fires. Inside, the screams slowly died. Once the wreckage was a smoldering, burned-out husk, firemen pried open the doors and found a fused pile of bodies there. The heat had been so intense that the bodies were nearly melted together. Once the bodies were pried apart, they found that thirty-three passengers had lost their lives in the blaze.

This accident was the final straw. Those in the city council now had a further reason to push for a bus system and removal of the tracks and the cars. Although the streetcars managed to last a few more years, the sheer horror of the accident that evening made them less and less popular.

Slowly, the streetcars were removed from service and sent to yards to rust. The tracks were torn up from the street, and the streets were widened. The wires were taken down. Only about eight years after the crash of

the Green Hornet, the streetcar system in Chicago was gone and buses and subways were the norm.

THE FRESH WATER TIDAL WAVE

Lake Michigan is not as big as an ocean, but it is a large inland sea. It can be as unpredictable as the ocean. Storms often pop up unexpectedly and can be very intense. The Midwest is also known for its unpredictable weather.

Storms often come through the Chicago area. More often than not, they form strong lines as they travel from west to east. However, as they reach the lake, the cooler waters often sap the strength out of these storms. Still, the high pressure systems that accompany them remain strong.

In the ocean, tidal waves happen thanks to massive underwater disturbances. Earthquakes can cause tidal waves to go racing along beneath the surface of the oceans, barely noticeable on top until they crash into shore and destroy lives and properties. Sometimes, underwater landslides and volcanic disturbances also contribute. What most people don't know is that something similar can happen in places like Lake Michigan. When they happen here, they are known as seiches.

What creates a seiche has to do with the thunderstorms that come ripping through the area. These storms build

up a massive pressure front. The air in front of these storms presses down on everything below, including water. When the storms reach a place like Lake Michigan, the pressure pushes down on the water, forcing it away from shore. These storms move rapidly, and the water pushes ahead, building and building. Once the storm either dissipates or reaches the other side of the lake, the effect is like letting go of a rubber band. The water snaps back the way it came, forming a freshwater tidal wave that moves slower than an ocean tidal wave but can be just as deadly.

In June 1954, one of these seiches hit the Chicago area to devastating effect. Today, the National Weather Service monitors storms and issues seiche warnings. In 1954, the weather predictions were more science fiction than anything close to reality. As such, no one knew about seiches or what might happen after severe storms had passed through.

On the morning of June 26, a line of severe thunderstorms had passed through the area, drenching the city and wreaking some minor havoc. As the storms passed over the city and then over the lake, they pushed a small wall of water ahead of them. Behind the storms, spectacular summer weather was in store. It looked like nothing could possibly go wrong. Since it was supposed to be hot, many decided to head to the lake to fish, swim or just stand near the water and catch some breezes.

However, the storms soon reached the edges of Lake Michigan on the far shores of Indiana and Michigan. The storms had generated wind speeds in excess of sixty miles per hour. The wall of water ahead of the storm system was significant. However, once the storms reached the shore, that wall of water did what water does and snapped back, rushing toward Chicago's shore.

The early hours prevented those on the Chicago shore from noticing that the water level had gone down. The water was moving back toward Chicago, but at a pace of about thirty miles per hour. By the time the wave reached Chicago, it had reached a height of five and a half to six feet.

Fishermen were lined up on the North Avenue Pier. Several were laying face-down, watching their lines and studying the movements of fish. Most were chatting, but some kept silent. Suddenly, the water rose to meet them.

Unlike in the movies, seiches and tidal waves do not tend to grow to monstrous heights and then come crashing down on unsuspecting beaches or cruise ships. They simply wash over the shoreline and then keep washing forward, pushing everything in their paths. Seiches rush in, grab what they can and then rush back out, taking life, limb and property with them.

The water washed over the North Avenue pier and swept the fishermen away like a hand swatting at flies. Then it kept going, washing over the beaches, rushing up

Lake Shore Drive, into the parking lots and almost to the brink of the city itself. Then, suddenly, it receded almost as rapidly, taking everything it had picked up with it.

Roughly a dozen or more fishermen were washed out into the receding water, finding themselves suddenly in the middle of the lake. Those on the shore stood in stunned surprise. The hardiest of bystanders immediately ran into the waters to rescue the screaming and flailing men. Many were pulled, gasping and dripping, from the water and revived. Eight men, however, were not so fortunate, and they drowned in the waters of Lake Michigan.

The city was stunned. Seiches were not something anyone talked about. They remain a rarity, but now the city knows that they can happen. There have been several seiches since 1954, but there has been nothing to match the death toll of that day, when eight lives were washed away in a blink of an eye.

TALES OF ILLINOIS' THUNDERBIRDS

There are tales of large birds flying around Illinois that go back to Native American times. One of the most famous, known as the Piasa bird, is still painted on rocks that overlook the Mississippi River near a town called Alton. These strange paintings were first documented by

Lewis and Clark as they made their historic trek across this land so many years ago.

According to legend, the Piasa bird was a giant bird with horns like an elk, a face like a man, the wings of a bird and a tail so long that it could wrap around the creature's body. The bird reportedly terrorized Indian lands many, many years ago, taking men, women and children screaming to their deaths in its terrible talons. A brave Indian chief allowed himself to be bait for the giant bird while his best hunters hid in ambush. When the bird swooped down to get him, it was struck down by arrows.

That is the legend, of course. Such giant birds could not actually exist—certainly not birds with faces like humans and the rest of their bodies a hodgepodge of other animals. But legends of giant birds have shown up again and again in Illinois history, and not so terribly long ago.

Some of the earliest documented sightings of giant birds capable of carrying off humans go back to Missouri in the 1800s. According to one report, an eight-year-old boy was picked up and attacked by a giant bird, which one of the boy's teachers described as an eagle. The bird reportedly swooped down while the boy was outside with friends and carried him into the air before screams from down below caused it to drop him. The boy was killed by the fall. There were other reports in the area of "eagles" carrying off and attacking livestock such as pigs and lambs.

However, in Illinois, you need only go back as far as 1977 to read about giant birds and attacks on children. These birds have come to be known as Illinois "Thunderbirds," after more Native American legends. The 1977 incident was reported in Lawndale, Illinois.

It was evening on July 25 when two giant birds suddenly appeared in the skies over Lawndale. They hovered, swooping and flying in circles, over the town for some time, long enough to be reported by several residents. As these people watched, the birds circled like hawks before diving straight down and attacking a group of three boys playing in the backyard of Ruth and Jake Lowe.

One bird grabbed the shirt of Marlon Lowe. As the boy screamed and tried to fight the giant bird, its talons sunk deep into the fabric and began lifting the boy into the air. The screams of Marlon and those who were playing with him attracted attention. Marlon's mother came running outside and later told authorities that she saw the bird lift Marlon off the ground and several feet into the air.

She screamed and waved at the bird, and the bird got scared, releasing Marlon. The boy fell to the ground, but he had only been a few feet in the air. His mother told authorities that she was certain if she had not come out when she did the bird would have carried him off. She also stated that the giant bird had been bending down, trying to peck at Marlon's face and eyes as it flew with him twisting in its talons.

As Marlon's mother ran to help him, four other adults appeared, attracted by the commotion. They, too, reported seeing the birds. They described the birds as black, with bands of white around their necks. They also reported long curved beaks and wingspans of at least ten feet across.

As police arrived, they began taking statements, trying to sort out what had happened. The story was, of course, incredible, but with so many witnesses, it was taken seriously. As for the Lowe family, they found that there were plenty of others in town who were unwilling to believe them, no matter how many witnesses had

showed up. They were harassed and teased. Marlon was particularly bothered in school.

There were hypotheses about what the birds might have been. Some suggested they were just turkey vultures. Marlon's mother vehemently denied that that was what they were. She knew what turkey vultures looked like, and these birds were much bigger. Still others have suggested that they were condors, although no one has ever been able to prove one or the other.

Three days after poor Marlon was nearly carried off, a farmer in McLean County said that he saw a bird about the same size as those described in Lawndale. He and his family and some friends were outside watching model airplanes when the giant bird suddenly appeared, flying close to the planes. The farmer speculated that the wingspan of the bird was at least ten feet.

Just a few days later, in Bloomington, Illinois, a postal worker driving a mail truck reported that he saw two birds in the air and watched as one suddenly swooped down into a field and carried off a small animal. He suggested that the birds were condors, but they were abnormally large, with ten-foot wingspans. He claimed that the small animal was likely a pig.

On July 28, a woman named Lisa Montgomery in Tremont, Illinois, was outside washing her car when she looked up into the sky after a strange shadow passed over her. She reported seeing a giant bird with a wingspan of at least seven feet slowly circling in the

hot summer air. She said the rest of the bird appeared black, with a low tail, and she watched it until it disappeared toward Pekin.

July 30 arrived and with it, another report of giant birds. This time it was Dennis Turner and some of his friends in Downs, Illinois, who saw the creatures. They claimed to have seen a gigantic bird perched on top of a telephone pole. As they watched, the bird suddenly dropped and attacked something on the ground. When they later walked over to the spot, they found a large rat lying dead on the ground. During that same time, the people of nearby Waynesville claimed to have seen a giant black bird with at least an eight-foot wingspan flying overhead.

Bloomington and other central Illinois cities continued to report sightings of giant birds. On July 30, a man who worked as a writer and a construction worker named "Texas John" Huffner was out fishing. Huffner was in his boat with his son when they spotted two giant birds roosting in a tree. He blew the boat's horn and scared the birds, and he had enough time to grab a camera and film them as they flew off. This footage ended up on the newscast of a Champaign, Illinois television station. Huffner claimed that the wingspan of the birds he saw reached over twelve feet.

Even experts were unable to determine what the birds were. The Department of Conservation dismissed the claims of monster birds as hysteria. Their contention

was that the birds were merely turkey vultures and nothing strange or out of the ordinary. However, wildlife experts and those familiar with cryptozoology stated that turkey vultures did not reach the sizes described by the witnesses. The largest bird in all of North America is the California condor, and it has an average wingspan of nine feet.

On July 31, Mrs. Albert Dunham was in a rural area not far from Bloomington, on the second floor of her house, when she saw a shadow pass by the windows. Having heard the stories of the giant birds, she figured that this must be one and ran to the window. She saw the bird flying away, and when she described it, it matched the descriptions of other witnesses in other parts of the state. Her son also saw the bird and gave chase, all the way to a local landfill. Mrs. Dunham called the local paper, and a reporter chased after her son. The bird was gone before the photographer was able to get a picture.

On August 11, John and Wanda Chappell were out and about in Odin, Illinois, when they spotted a giant bird in a tree. They claimed it was grayish black and had a twelve-foot wingspan. John stated that he thought the bird looked prehistoric. Both John and Wanda felt that the bird was large enough to have carried away their small daughter had it spotted her.

The sighting in Odin was the last large bird sighting in 1977. Just as quickly as they had started and spread across the state, the reports stopped. Some believe that

the birds are real but that the bad press assigned to those who were reporting them caused people to stop reporting sightings.

To this day, there are reports of giant birds in parts of Illinois. In 1977, even though the press stopped spreading the stories, there were a couple more sightings. On August 15, in the town called Herrick, a witness reported seeing two giant birds. This witness estimated the wingspan at ten feet.

On August 20, a man named Paul Howard reported seeing a giant bird in Fairfield, Illinois. He claimed that the bird had landed in a field near his car and remained there, giving him a good look, for several minutes. He estimated the wingspan at twelve feet.

Still another witness has since stepped forward, saying that on November 1, 1977, she looked out the back window of her home and saw a giant bird on top of a tall tree in her backyard. She claimed the bird was much larger than any bird she had seen before. It stayed there for a few moments and then took off into the sky, and she guessed the wingspan to be between ten to fifteen feet.

Claims still surface. To this day, no one knows for sure what kinds of birds people may have been seeing, or if they were seeing anything at all.

THE ROSEMONT HORIZON ROOF COLLAPSE

Chicago is such a large city that even the suburbs have sports teams and venues. Not everyone who lives out in the suburbs can make it downtown, and events cost money. As such, many suburban cities have built stadiums to house family-friendly sports teams, as well as provide a venue for concerts and other events. One of those arenas is now known as the All-State Arena, but it was first known as the Rosemont Horizon.

Rosemont is a suburb just barely outside of the Chicago city limits. It is right up against O'Hare Airport, and major highways bisect it. Located near the toll road that runs through the town is an area where the stadium now stands. People come there to visit the minor league hockey team known as the Chicago Wolves. The parking lot is also the home of a large flea market. Concerts are held there. Hundreds and hundreds of city and suburban men, women and children pass through the doors of the All-State Arena for a wide variety of events, from sports to the circus.

Compared to some of the stadiums downtown, the arena is a bit small. However, when you look up at the roof and see the wooden beams that crisscross the ceiling and support the roof, you may wonder how it stands the vibrations of the airplanes, which feel like they are nearly landing on the roof. What many who stand in the stadium don't recall is that the roof did fall, and the disaster took the lives of five workers.

The stadium was 90 percent complete on Monday, August 14, 1979. One-third of the roof had been placed. The original design for the roof was for sixteen glue-laminated wooden arches, 6.1 feet deep, to span 288 feet. Each of those wooden beams was actually composed of three different pieces, placed in three stages. The wooden beams connected to concrete columns at the end of each beam, and concrete buttresses bore the load on underground blocks. All of this was designed to reduce the amount of noise created by the traffic at the airport.

What led to the deadly collapse were with the pieces that held the three parts of the wooden beams together. Each arch was tied by a 3.1-foot-deep girder, set by three purloins. Angle irons were then placed to hold the girders together. Those angle irons were affixed to the beams using several bolts and then to the girders with three bolts. This was supposed to allow the stages to be set a bit at a time and, had the procedures been followed, would have allowed construction to continue without a glitch.

The problem was that corners were cut. It was decided and approved by the supervising engineer that two of those three bolts that held the girders together were unnecessary. This would allow the wood to deform downward while the rest of the girders were placed. The deformation was to take place under the purloins and deck loads just before the other bolts were installed. In order to compensate for the lack of those bolts, a subcontractor

was hired to create steel plates as temporary connectors to the arches and girders.

Still further corners were cut as construction continued. On August 14, as the roof and wooden beams high above what would become the floor of the arena were covered with workers, those beams suddenly gave way. In a horrendous crash, the beams fell and took the men with them. When the dust had settled and the rescuers had pulled away the rubble, five men lay dead, crushed and broken beneath the beams. Sixteen more were injured.

The investigation by the Occupational Safety and Health Administration began almost immediately, as the rubble still lay beneath what should have been the roof. Before long, the cuts that had been made while placing the roof became evident as the cause of the collapse. Over 53 percent of the bolts that were required to connect the beams were missing. There were 944 girder bolts that should have been in place in the girders that were already set. The investigators found only 444 in place.

Things managed to get even worse from there. Of the 444 bolts in place, 338 had no nuts to affix them properly. Those that did have nuts had not been tightened with any kind of power tool. In addition, the steel plates that had been created to support the beams when the bolts were being deliberately left out had not been installed properly, and only 27 percent of them were in place.

Ultimately, it was a combination of things that caused the collapse. The inadequate supports were the biggest

factor. However, the workers had also been stockpiling materials on the beams and the parts of the roof that had been built. The added weight caused the beams to bend. The area around the arena was free of trees, so the wind would head right across the roof and the

beams, adding additional stress to the weakened and unsupported beams. Finally, the airplanes and traffic caused vibrations that gradually shook the beams. It was a combination of natural forces and negligence on the part of the workers.

Ultimately, OSHA fined the architect of the project. The other subcontractors involved in the building of the Horizon were also fined. OSHA even fined the independent engineering firm that was hired by the city to investigate the disaster for unnecessarily exposing their employees to fall hazards during the field inspection process.

Just one year later, another collapse took place on the still-unfinished Rosemont Horizon. Concrete stands being built collapsed and deposited thirty-four tons of concrete to the ground. Thankfully, although it was a huge mess, there were no fatalities.

The Rosemont Horizon was eventually completed. It has remained safe to this day, with the many hundreds and thousands of people visiting the stands and the stadium to watch sporting events and concerts. There is a small plaque to memorialize the workers who lost their lives, but very few who sit in the seats these days know the blood that went into the construction of the stadium.

THE HOUSE OF CROSSES

Chicago is full of strange landmarks. Some of them are very old, like the water tower in downtown Chicago, famous for being one of the last buildings to survive the Chicago Fire. There are strange sculptures that most Chicagoans do not understand, such as the Picasso piece on Daley Plaza. One of the oddest, however, was the House of Crosses.

Today, there is little, if any, sign of this strange building. The house itself is gone. The crosses that covered the house are gone. Even the tree that stood outside the house and was as much a landmark as the house is gone. Everything disappeared in 2007. Before that, however, those who were interested in finding strange things and odd landmarks knew about the House of Crosses.

Located on West Chestnut Street, the house was hard to miss. Before the owner started affixing the hundreds of crosses to the surfaces, the house was nothing special. It was red brick and shorter than the two white buildings on either side. It was two floors and had a simple concrete front porch leading up to the door.

The house was owned by a man named Mitch Szewczyk. It had been on that spot since 1879 and was built by a Polish immigrant. That man used the house to court his bride and bring her to Chicago. They raised a family there, and one of their children, Mitch, moved into a coach house behind the main building.

Eventually, Mitch moved into the upstairs apartment to take care of his elderly mother, and sometime after that, he began decorating his apartment with crosses.

Mitch was a devout Catholic. He had a fascination of the Crusades and medieval history. He made many of the crosses and shields that came to decorate the house himself. To add to the strangeness, however, he made these crosses and shields out of things he found in the streets and alleyways.

Mitch never intended to do anything with these crosses and shields. He never intended to cover the house with them. He enjoyed making them and collected them in his rooms and other parts of the house. When Mitch's mother passed away in 1977, the neighborhood he had grown up in was a lot different from the one where his father had built the house.

Gangs ruled the neighborhood and roamed the streets around the house. Mitch decided to hang a single red cross from the front of the house. He did that in hopes that it would discourage people from bothering him and his house. To nearly everyone's surprise, it seemed to work; he was not bothered, and his house was not broken into.

Mitch continued to make crosses in his spare time, along with the shields. Starting in 1979, he began nailing them around his house. Mitch was no longer putting the crosses on his house for protection but was now developing a pattern as a tribute to saints and popes. He also started

putting up crosses as a tribute to local politicians and movie stars. He even created crosses dedicated to fictional characters, such as Tarzan or Zorro.

As he continued to look for themes and people to create crosses for, he began creating more and more of them for movie stars. The house was starting to fill up on the outside and to generate some attention. Crosses dedicated to Sammy Davis Jr., Mickey Rooney, Bing Crosby, Zsa Zsa Gabor, Lancelot, Bette Davis, Buckwheat and the Cisco Kid began to appear. He made crosses for former Chicago mayors, such as Jane Byrne, and religious figures, such as Pope John Paul II. When Pope John Paul II visited Chicago, his entire caravan stopped in front of the house to see the shrine.

Mitch kept making crosses, and he kept adding them to his house—up the sides of the building, onto the roof and down the other side. More and more people were traveling down the street to see this strange house.

Mitch eventually became ill in the 1990s. He was working on what he considered his masterpiece, the King Kong cross. According to Mitch, it was going to be the biggest and the best cross he had ever made. However, Mitch was soon bedridden and unable to make his beloved crosses. A few years later, he died.

Mitch's family held on to the strange house and continued to live there after he passed. However, the house was starting to fall into disrepair. Keeping the house up was becoming too difficult for the family,

and it was starting to become an eyesore rather than a tourist attraction.

The neighborhood was also starting to change again. Developers had moved in and were starting to tear down the old houses and buildings and turn them into condos. Residents were selling their houses at outrageous prices and letting these developers turn their homes into condos.

Mitch's family finally had enough. The younger members of the family had no interest in staying in the house, and Mitch's sister was getting too old to keep the house in repair. She contacted one of the developers and sold the house. A piece of Chicago history was on its last legs as the developers moved in to turn the house into condos.

The house is gone now. In its place stand fancy new condominiums. They are full of modern amenities, but they don't have the character of the House of Crosses. Exactly what happened to the crosses themselves, no one knows. Presumably, they have been passed around to the various surviving members of Mitch's family.

THE DEADLY HEAT WAVE

Most people who have never been to Illinois or Chicago seem to assume that it is cold year-round. If you talk to anyone, particularly those who live in southern climates, about Chicago, they will likely tell you that the

city is "too cold." Of course, during the winter months this is all-too true. What people seem to forget is that Chicago and Illinois have a summer as well. During the summer months, the temperatures in Chicago and the Midwest easily reach the triple digits. Compounding this problem, the air is often saturated with moisture, creating intense humidity that causes the heat index to rise to dangerous levels.

In Chicago, there are additional problems when the heat rises. Metropolitan areas generate a tremendous amount of heat. The buildings absorb that heat throughout the day and then radiate it out at night, so the areas never get much of a chance to cool. The pavement absorbs the sunlight; at times, the asphalt starts to melt and buckle. Again, once the sun goes down, the pavement radiates that heat, keeping the temperature high even when the sun is down.

Heat has a cumulative effect on the human body. A day or two of dealing with the heat and the body can survive as long as it is rehydrated. However, the body finds it harder to recover the longer the heat wave goes on. Often times, it takes only a couple of hours in a cool room for the body to recover, but sometimes citizens are unable to find that relief, and their bodies keep reacting to the heat.

Additionally, in Chicago there are many poor residents who cannot afford air conditioning. There are also residents who are unwilling, or even unable, to open their

windows. This situation can quickly become dangerous, which is exactly what happened in the summer of 1995, when Chicago found itself in an unprecedented heat wave that took hundreds of lives.

The entire summer had been very warm. This was particularly true during the month of July. The hottest days, however, were from July 12 through July 16, and these were the most deadly. The highest temperature recorded during those days was July 13, when it soared to over 106 degrees. This set the record for the hottest July temperature since records had started being kept on the subject.

The problem was that the temperatures were not getting to comfortable levels at night. The nighttime temps reached the high 70s or low 80s, and the humidity stayed high. There seemed to be no relief in sight for anyone. Heat indexes reached as high as 119 or 125 degrees, depending on which airport was reporting the temperatures.

There had been heat waves to hit the city before, of course. In 1854, 1930, 1976 and even 1988, the city baked. The major difference between those heat waves and this one, however, was the humidity. Although each of the years mentioned had days of high humidity, the extended days of endless humidity that hit in 1995 were not as common.

As the days wore on, people started flooding hospitals with heat-related problems. Most of them were suffering from severe dehydration and heat

stroke. As the days wore on, the consequences began to turn deadly. The victims were noticeably elderly and poor, living somewhere in the heart of the city where they were unwilling to open their windows due to high crime rates in their neighborhoods.

These victims were checked on by relatives and neighbors after city officials went on television and asked that elderly relatives and neighbors be checked. Many were found dead in their homes, their windows shut tight, perhaps only a fan blowing hot air around a stagnant room. The bodies began to pile up fast. Soon, hospitals and morgues were overwhelmed. They were unable to accommodate the sheer numbers.

The media began to catch on and reported the high death tolls. It soon became very obvious that the city was divided between those who could afford air conditioning and those who could not. The line between the poor and the middle class and wealthy never seemed more apparent. The dead also seemed to be divided between sexual lines, in addition to those of race.

Women seemed less likely to be found dead. This was attributed to the fact that women are more likely to be social or active in their community. They were more likely to have people who would check in on them. Men, however, were more likely to isolate themselves or to have lost contact with their families.

Society itself was different than in past heat waves. For example, during the 1930s, when the heat was bad,

people slept outside. In fact, people were encouraged to sleep in local parks or near the lake. Given the risks involved in doing that during a modern heat wave, there was no place for many of these people to go.

The City of Chicago was slow to realize what was happening. City officials at first seemed to be going to great lengths to deny that the heat had anything to do with the sudden and dramatic rise in the death toll. As reporters and television crews showed bodies being put into refrigerated trucks outside morgues because the morgues were so full, the city was busy denying there was a problem. Since the city said there was no problem, there was no official response to help those who might need it.

The city had failed to warn the citizens properly of the heat. The weather service was also to blame, not issuing heat advisories in a way that anyone could react properly. The city also had problems with its power system; the huge drain on the electrical supply of Chicago caused blackouts. The city ambulance services were taxed to the brink, and they were simply unable to respond to all of the calls pouring in. There were only five cooling centers active at that time in Chicago, but most people did not know how to find them or had no way to get to them.

The other problem was that the air over Chicago simply became stagnant and did not move. This was a problem for those already experiencing health problems such as asthma or emphysema. The stagnant air caused

the pollution to sit over the city, turning the air itself dirty. This contributed to the deaths.

Exactly how many died because of the heat that summer may never be known. Even now, the city is unwilling to admit that all of the deaths that week were due to the heat. What is known is that 739 people above the average death toll for the city died that week. Most guess that the deaths due to heat number around six hundred or more

While the city took no official blame in the deaths that piled up that summer, it has done things to make sure it never happens again. More cooling centers have been opened throughout the city. Whenever a heat wave is predicted, the city springs into action. The fire department and police force start knocking on doors and delivering fans, making sure that those who live in poor neighborhoods or who live alone are visited and taken care of. The city has suffered heat waves since 1995, but there has been no repeat of the deaths experienced that terrible summer, when the city baked and hundreds died.

THE DEADLY PORCH COLLAPSE

Chicago has a number of neighborhoods that are popular with young people. These are generally around the

colleges and universities in the city. Here, the apartments tend to be relatively affordable but often occupied by many students. These are the places where college kids have their big parties.

One of those neighborhoods is Lincoln Park. It has been the trendy neighborhood for a very long time, not far from DePaul University and close enough to downtown activities to make it especially appealing. Bars and clubs run up and down the major streets throughout Lincoln Park, and these are interspersed with wealthy homes and fancy lawns.

Many of these apartment buildings are old. They have hardwood floors mixed with modern amenities. Behind these buildings are wooden balconies and porches. At one time, these may have been made of metal and were quite small, but these days they have become extensions of the apartments. Often, they are gathering places, more like decks than just stairs and platforms to get up and down the back of the building.

On June 29, 2003, one of these wooden structures collapsed. The disaster was horrific and ignited a scandal as corruption in the parts of the city government that are supposed to inspect these structures became evident. Meanwhile, the deaths of many college-aged students brought the city into mourning. It is the deadliest porch collapse in U.S. history.

The apartment was occupied by students attending colleges in the area. The day was meant to be a party

that would unite friends from New Trier and Lake Forest High Schools. The party was to take place on the second and third floors and spill out onto the wooden porches or balconies attached to the brick structure behind the building. No one seemed concerned.

The night was warm. The apartments were soon crowded. People began heading for the cooler breezes on the back porches. Soon, the second- and third-floor porches were covered with college students. Some witnesses insist that some of them were dancing or even jumping upon the balconies. Others say they heard nothing and saw nothing out of the ordinary.

There were about fifty people on the top, or third-floor, balcony when the accident occurred. It was just after midnight, and the party was still in full swing. Witnesses inside the apartment say that they heard a horrifically loud twisting and splintering sound. That was the sound of the wood balcony splintering and the metal bolts that were supposed to hold the balconies to the wall tore out.

The effect was devastating. The balcony on the third floor pancaked down on the second floor. The two balconies then fell onto the first floor, which then collapsed into a stairwell that led into a basement. A grand total of one hundred people were buried beneath tons of rubble.

The sound was horrendous, but if there was a bright spot to the disaster, it was that some of the students were nursing students or had studied medicine. Almost

immediately, an emergency triage area was created in the backyard of the apartment building. Survivors immediately ran downstairs and began carefully pulling the rubble apart, pulling broken and battered bodies from the twisted wood and metal.

The Chicago Fire Department arrived almost immediately. They were part of the Special Rescue division, and they began taking over the main rescue effort. Eleven dead bodies were pulled out of the rubble that night. Fifty-seven people were injured and rushed to local hospitals. Two more died from their injuries in the coming days.

The city was outraged, and an investigation was implemented. The initial findings of the fire department were that the collapse had been due to overcrowding. Neighbors and some witnesses corroborated this. The balconies were supposed to hold between twenty and thirty people.

However, further inspection discovered that overcrowding may not have been the only cause. Poor construction was also at work. Back in 1998, the owners had gotten a permit to put furnaces, air conditioners and water heaters into the building. The permit said nothing about building new balconies, but the owners gave the contractors permission to go ahead and build new balconies.

The problems with the balconies was that they were not built to specifications. The balconies jutted out from

the back of the building eleven feet, which is one more foot than regulations permitted. The entire area of the balconies was 231 square feet, 81 square feet bigger than permitted. Finally, the supports for the balconies were inadequate, and the flooring was composed of undersized wood, which, in turn, was affixed to the walls with screws that were too short.

Three days after the disaster, the city brought a lawsuit against the owners of the building due to the breaches in the housing and building regulations. It also named the contractors who had built the balconies. It was seeking $500 for every day the structure was in existence. The total was hundreds of thousands of dollars.

Meanwhile, more inspectors began checking out other structures and balconies. Ultimately, 500 cases were turned into the city's Law Department for some kind of court action. Approximately 760 cases were then referred to administrative hearing officers.

The owners continued to protest that the cause of the collapse was overcrowding. However, some reporters checked out other buildings owned by the same company and found that signs had been installed forbidding parties on the balconies. Despite this, the owners were able to produce witnesses who said that they saw people jumping on the balconies just before they collapsed.

Ultimately, no criminal charges were brought against the owners or the contractors. However, the owners were fined $180,000. After that, twenty-seven families sued

both the owners and the city because the inspectors and their qualifications for the job had been found lacking.

The balcony behind the building where the accident occurred was eventually rebuilt. This time, the balcony was made of metal.

Visit us at
www.historypress.net